3 9082 08073 3903

D0861069

JAN 16 2001

BLACK AMERICA SERIES

BLACK BASEBALL
IN DETROIT

TRENTON PUBLIC LIBRARY

TRENTON PUBLIC LIBRARY
2790 Westfield Rd.
Trenton, MI 48183-2482
Ph. 313-676-9777

16

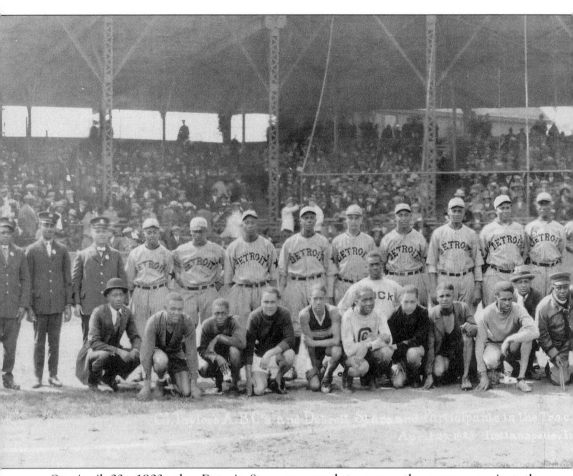

On April 23, 1923, the Detroit Stars prepared to open the season against the Indianapolis ABC's in Indiana. Amid the fanfare, marching bands, and match races, this was a banner year in black baseball. For the first time, the Negro National League would use black umpires—Billy Donaldson of Los Angeles, B.E. Gholston of Oakland, Caesar Jamison of New York, William "Cap" Embry of Vincennes, Indiana, and Leon Augustin and Lucian Snaer, both of New Orleans. Tom Johnson, a former player, was named as a reserve umpire. (Courtesy of NoirTech Research, Inc.)

BLACK AMERICA SERIES

BLACK BASEBALL IN DETROIT

Larry Lester, Sammy J. Miller, and Dick Clark

ARCADIA

Copyright © 2000 by Larry Lester, Sammy J. Miller, and Dick Clark
ISBN 0-7385-0707-5

Published by Arcadia Publishing,
an imprint of Tempus Publishing, Inc.
3047 North Lincoln, Suite 410
Chicago, IL 60657

Printed in Great Britain.

Library of Congress Catalog Card Number: 00-101318
For all general information contact Arcadia Publishing at:
Telephone 843-853-2070
Fax 843-853-0044
E-Mail arcadia@charleston.net

For customer service and orders:
Toll-Free 1-888-313-BOOK

Visit us on the internet at http://www.arcadiaimages.com

3 9082 08073 3903

CONTENTS

We would like to thank the following people for their personal commitment to this wonderful chapter in African-American history:

Richard Bak, Paul Debono, Lou Dials, Frank Duncan III, Lisa Feder, John Holway, Joi Lester, Jerry Malloy, Gene & Barbara Miller, and Nettie Stearnes.

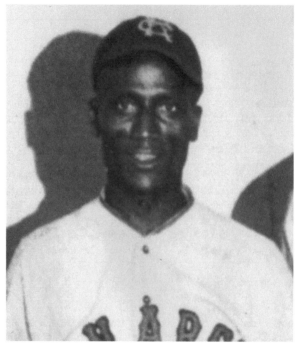

Whistle Stop: Black Baseball in Detroit is dedicated to Detroit's greatest black player and his induction to the National Baseball Hall of Fame in Cooperstown, NY. - Norman "Turkey" Stearnes

INTRODUCTION

The 1910 census reported Detroit's black population to be 5,741 citizens, with approximately 25 owning a business. Ten years later, African-American entrepreneurs owned roughly 350 businesses, including a movie theatre, a co-op grocery, a bank, and most importantly, an all-black professional baseball team.

Chicago tycoon Andrew "Rube" Foster owned the city's first professional black team. Known as the "Godfather of Black Baseball," Foster founded the Negro National League (NNL) in 1920. Besides owning the Chicago American Giants, he had majority interest in the Detroit club and the Dayton Marcos. Published reports often referred to African-American John T. "Tenny" Blount, a local gambler, as the team's owner. Blount, lacking sufficient capital to own the franchise, was really the Detroit Stars' general manager. Blount was responsible for scheduling games at Mack Park, arranging transportation, and booking lodging accommodations.

John A. Roesink, a Dutch Jew from Grand Rapids, owned Mack Park. The park was located at Mack and Fairview Avenues in the heart of the German, working-class community, about four miles north of downtown. The single-decked structure seated between 6,000–10,000 spectators on its wooden benches.

The Detroit Stars originated in 1919 with J. Preston "Pete" Hill as their field manager. Approaching 40 years of age, the former all-star had been captain of Rube Foster's Chicago American Giants during the war years. Added to the mix were top quality pitchers Jose Mendez, Frank Wickware, catcher Bruce Petway, and middle fielder Frank Warfield. In their initial year of competition, the Stars won the integrated Michigan Semi-Pro Championship tournament. It was the first of five state titles in a row.

During the twenties, the Stars were comparable to their white counterparts, the Tigers; having superb hitting and less-than-spectacular pitching. Like the Tigers, they often finished near the top, but never quite reached that pinnacle of success. In the first league year, they won 35 of 58 games, a winning percentage of .603—good enough to win a pennant in most years, but Foster's American Giants won 32 of 45 games to finish first, three-and-a-half games ahead of the Stars.

In 1921, the Stars fell to fourth place behind the American Giants, the Kansas City Monarchs, and the St. Louis Giants, playing .500 ball with a 32–32 won-lost record. In 1922, the Stars landed another fourth place finish, this time with a much better 43–32 record. The Stars rebounded in 1923 to make a strong run at the champion Kansas City Monarchs, but finished five games back at 41–29.

The Detroit Stars snared third place in both 1924 (37–29) and 1925 (57–41), before dropping a notch to fourth place in 1926 (50–42). They continued to win the majority of their games, posting a 53–46 record in 1927, but finishing a disappointing fifth place. The Stars captured third place in 1928 with a 54–37 record, but fell to fourth place in 1929, with their first losing record, 39–42.

Mack Park, badly damaged by fire in July of 1930, forced the Stars to play in the newly built Hamtramck Stadium, located between Gallagher, Roosevelt, Jacob, and Conant Streets. Despite splitting play at two fields, the Stars finished second (50–33 won-lost) to the powerful St. Louis Stars. The following year, their last year in the league, the Stars slumped to a 32–36 won-lost record and fourth place. It was only their second sub-par finish in a dozen seasons as members of the NNL.

During the Stars' tenure in black baseball's first permanent league, they employed many quality players, with Andy Cooper being perhaps their most prolific hurler. The left-hander pitched from 1920 to 1927, and often led the staff in wins, with the exception of some outstanding performances from Bill Holland, Bill Gatewood, and Mendez in the early years.

Other noteworthy stars included Bruce Petway, perhaps the greatest catcher in Detroit baseball history. Elwood "Bingo" DeMoss, called one of the best second sackers in the game, managed the team from 1927 to 1931. In the early years, their top home run threat was first baseman Edgar Wesley. He was king, until Norman "Turkey" Stearnes arrived in 1923. With speed and power, Stearnes captured several home run titles, becoming a legitimate Hall of Fame candidate in the process.

When the Negro National League collapsed in 1931, a new Detroit team emerged in the fresh East-West League. The Detroit Wolves, owned by Pittsburgher Cum Posey, started the '32 season with the greatest assemblage of black talent in Detroit history. The Wolves lineup was dotted with future Hall of Famers, including "Cool Papa" Bell, Willie Wells, and "Smokey" Joe Williams, as well as several all-stars like Newt Allen, Ray Brown, George Giles, Ted Trent, Quincy Trouppe, and Mule Suttles.

Unfortunately, the aftermath of the Depression kept attendance low, and the league broke up after a few months of action. The Wolves were in first place with a 29–13 record before they disbanded. The new Stars, guided by Walter Norwood, proprietor of the Norwood Hotel, re-organized and played one season in 1933, finishing with a dismal 16–26 record.

Professional black baseball did not return to Detroit until 1937, bringing home a popular, but aging, Turkey Stearnes to roost. The Stars finished in the middle of the pack. Regretfully, the team did not return for the 1938 season. Two semi-pro teams sprang up in 1947, the Detroit Wolves (managed by Dizzy Dismukes) and the Detroit Senators (managed by Cool Papa Bell). They lasted one season. Detroit's black populace would suffer without a league team until 1954.

Enter another Grand Rapids businessman. This time African-American Ted Rasberry financed black Detroit's latest entry. Maintaining the Stars' name, Rasberry fielded an entertaining team until the Negro American League officially folded in 1960.

Foreseeing the demise of the league, Rasberry changed the team's name to the Clowns in 1958, and added acrobatic acts before the games, along with other creative attractions and promotions. They all proved futile in keeping black baseball alive in Motown. By 1960, the Stars' final year, they were advertised as the Detroit-New Orleans Stars. This last edition produced George Spriggs, an outfielder, who would later play in the majors for the Pittsburgh Pirates. There was also outfielder Dave Pope, from the 1947 Senators, who became a fine outfielder for the Cleveland Indians. With more and more Negro leaguers like Pope and Spriggs joining the majors, black baseball in Detroit would never flourish again.

One
THE EARLY YEARS
1883–1919

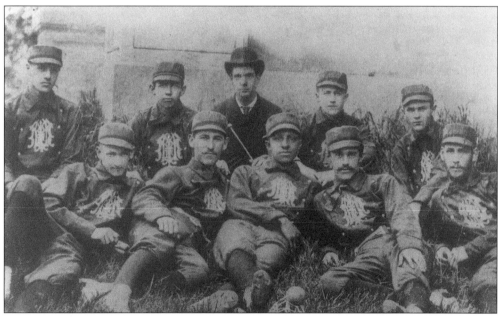

The University of Michigan was one of the few colleges in the country to have an integrated baseball team before 1900. The team of 1883, featured the following, from left to right: (front row) ? Condon, ? Allmendinger, Welday Walker, ? Packard, and ? Blackburn; (back row) ? Hueber, ? Montgomery, ? Metcalf, ? Miller, and ? McMillan. In 1884, Walker would become the second African-American to play in the major leagues when he joined his brother Fleetwood with the Toledo Blue Stockings of the American Association. (Courtesy of the University of Michigan.)

Pictured are the Page Fence Giants of Adrian, MI, in action. The team operated as a promotion of its sponsor, the Page Woven Wire Fence Company, from 1894 through the end of the 1898 season. The 1896 version of the team defeated the famed Cuban Giants, the most powerful black team in the East, to claim the "Colored Championship." (Courtesy of Jerry Malloy.)

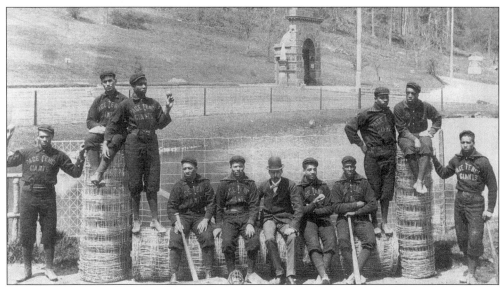

Formed by J. Wallace Page, owner of the Page Woven Wire Fence Company of Adrian, MI, the Page Fence Giants were one of the top teams of early black baseball. This 1895 version of the Giants were, left to right, ? Walker, Charlie Grant, George Wilson, John W. Patterson, Pete Burns, Augustus Parsons, unidentified, Grant "Home Run" Johnson, unidentified, Billy Holland, and unidentified. (Courtesy of Jerry Malloy.)

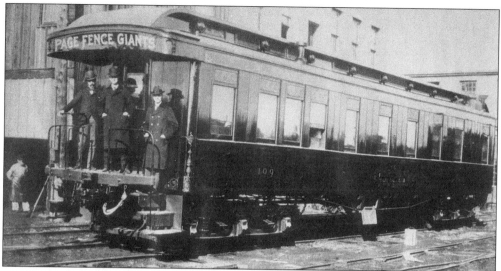

The Page Fence Giants traveled, known in those days as "barnstormed," across the United States and into Canada playing against all comers. They traveled in this custom luxury Pullman car. Team owners pose in their finery of double-breasted coats with bowler hats. The "109" on the side of the car was symbolic of the average victories for a season. (Courtesy of Jerry Malloy.)

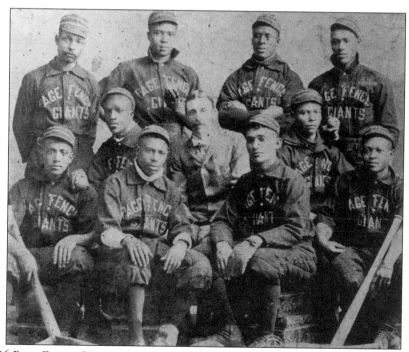

The 1896 Page Fence Giants were the premier team of the Midwest. They are as follows, from left to right: (front row) Fred Van Dyke, Jess Binga, Charlie Grant and Vasco Graham; (middle row) Bill Holland, Gus Parson (manager), and Pete Burns; (back row) George A. Taylor, George Wilson, Grant "Home Run" Johnson, and ? Walker. (Courtesy of the National Baseball Hall of Fame.)

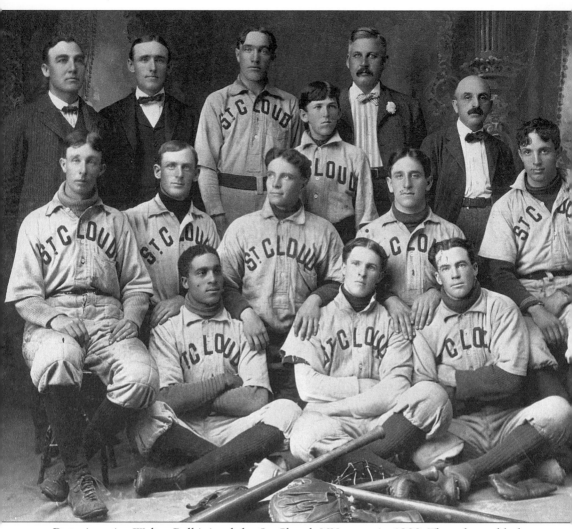

Detroit native Walter Ball joined the St. Cloud, MN, team in 1902. The talented lad was their ace hurler and played second base when not on the mound. Ball batted either clean-up or fifth in the lineup, giving evidence of a good bat. The other team members are as follows, from left to right: (front row) Ball (pitcher), Tom Scott (catcher), and Herbert Kilroy (pitcher); (middle row) Tim Lynch (shortstop), John Dominik (right field), Walter "Pee Wee" Chase (third base), Cy Bennett (second base), and ? Diggins (first base); (back row) Frank Thielman (secretary), John B. Pattison (manager), Dave Tucker (leftfield), O.H. Havill (treasurer), and David C. Abeles (president). (Courtesy of Stearns Historical Society.)

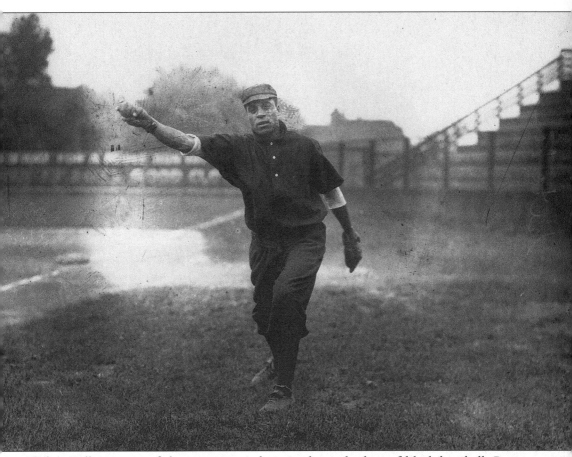

Walter Ball was one of the greatest pitchers in the early days of black baseball. Born September 13, 1877, Ball had an 18-year career that spanned 1906 through 1923. Ball played for some of black baseball's greatest franchises including the Cuban X Giants, the Leland Giants, the Chicago American Giants, and the Brooklyn Royal Giants. (Courtesy of Chicago Historical Society.)

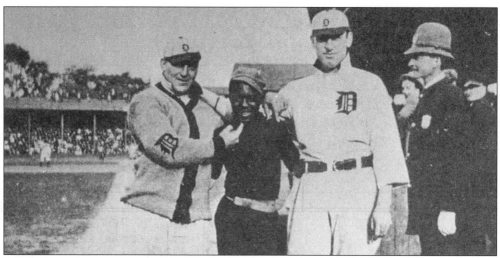

This photo, taken at Bennett Park in 1909, shows Detroit Tiger George Mullin with "Li'l Rastus" and an unidentified Tiger player. Despite the fact that Detroit Tiger (and vocal racist) Ty Cobb disliked playing in exhibition games against Negro League players, Li'l Rastus was his mascot. Most likely this comes from the belief that rubbing the head of an African-American brought luck. (Courtesy of Richard Bak.)

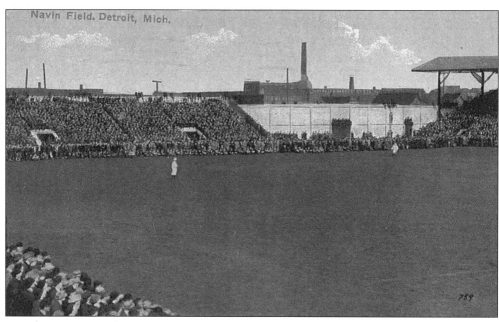

Standing Room Only (SRO) at a game at Frank Navin Field is illustrated by this picture postcard from 1913. (Tiger Stadium was known as Navin Field from 1912 through 1937.) At an original cost of $300,000, the park opened on April 20 at the same location as Bennett Park. The facility seated between 23,000 and 26,000 fans. The earliest recorded Negro League game played here was between the Indianapolis ABC's and the Chicago American Giants in 1917. (Courtesy of Dick Clark.)

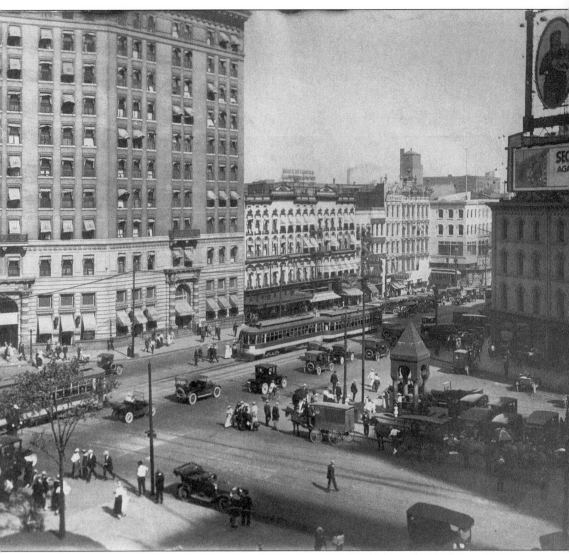

This photo shows downtown Detroit as it appeared during the early twenties. Bustling with activity and with money to spend, families were attracted to the city by the employment at the auto plants. African-American families settled near the eastside of downtown. The community became known as Paradise Valley or Black Bottom. Around 1936, Paradise Valley had its own informal mayor, Roy Lightfoot. (Courtesy of Richard Bak.)

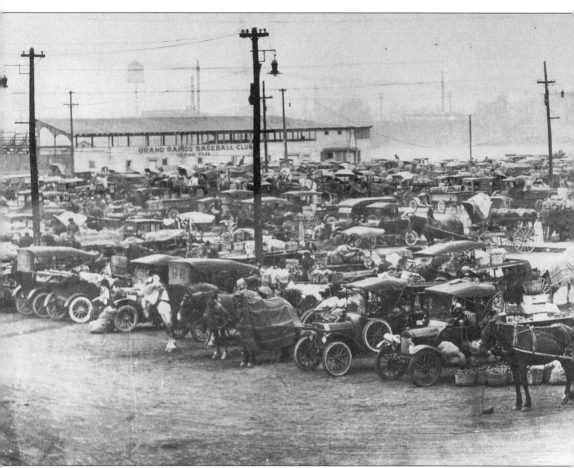

Push, pull, or tow, but get that buggy to the ball game. The early beginnings of tailgate parties in America are evident at this game played sometime around 1917 at the Island Park in Grand Rapids, MI. In 1909, inventor George F. Cahill experimented here with his portable lighting system for night baseball. Mayor George Ellis threw out the first ball for this historic event. (Courtesy of Grand Rapids Public Library.)

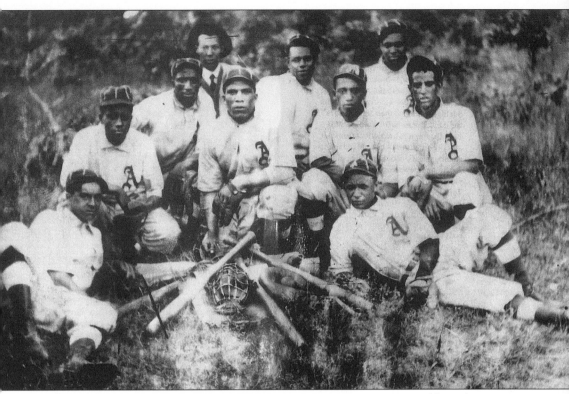

In addition to its major league-level black teams, the Detroit area, like other major metropolitan areas, was home to a number of all-black semi-pro and local teams. One was the 1919 Colored Athletics of Grand Rapids. Pictured are the following, from left to right: (front row) Clarence Mabin, Burton Grant, Walter Coe. ? Freemon, and ? Thompkin; (back row) ? Elbert, ? Strowder Earl Lewis, Jess Elster, and Herbert Pratt. (Courtesy of Grand Rapids Public Library.)

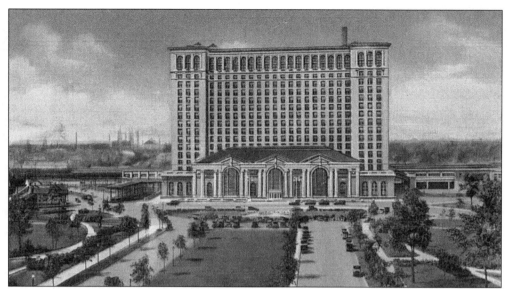

The Michigan Central Depot was the first sight travelers saw of the Motor City. The train station was the place of employment for many African Americans as Pullman porters, janitors, and shoe men. One of the more famous trains to use the station was the privately owned car of Detroit Stars' owner Rube Foster. The train carried Foster's other team, the Chicago American Giants, to games across the country. (Courtesy of Dick Clark.)

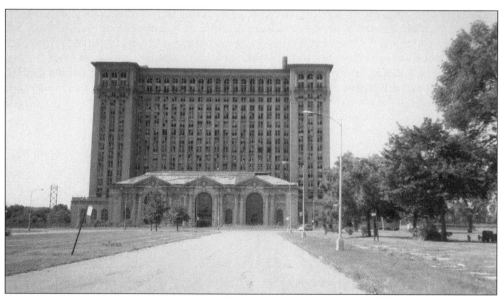

Pictured above is the Michigan Central Depot as it appears today. The station is one of the most important African-American history sites in the city. During the days when traveling by train was the preferred mode, the station was the Ellis Island of the Motor City to African Americans migrating from the South. The sight of the depot offered hope from segregation and racism, as well as relief from "whites only" signs of the Deep South. (Courtesy of Dick Clark.)

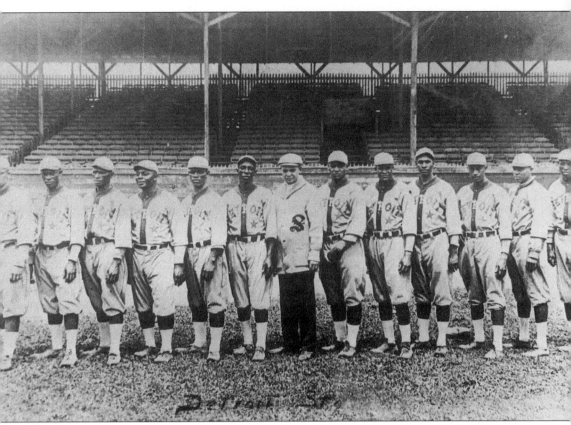

The Detroit Stars were first formed in 1919 with the help of future Hall of Famer Andrew "Rube" Foster. The talented players are, from left to right, unidentified, Joe Hewitt, Frank Warfield, Andrew Reed, Pete Hill, Jose Mendez, Tenny Blount (manager), Frank Wickware, Jose Rodriquez, Edgar Wesley, Bruce Petway, John Donaldson, and Sam Crawford. (Courtesy of Richard Bak.)

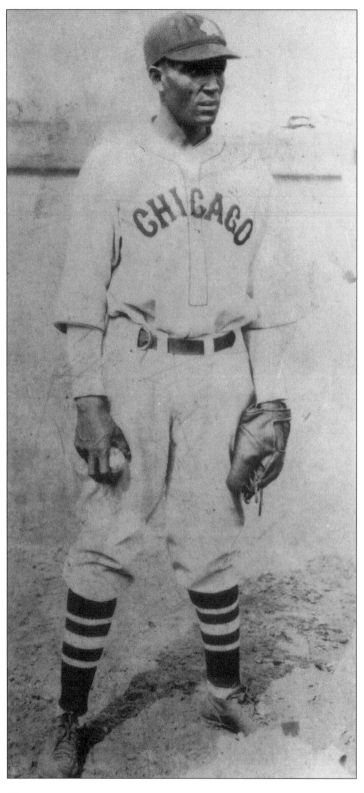

Dave Malarcher played for the Detroit Stars in 1919 after returning from service in World War I. A gifted third baseman and great clutch hitter, he was considered by some the greatest "hot corner man" in the game in the early twenties. Malarcher was lured away from the Stars the following year by Rube Foster, who needed a third baseman for the Chicago American Giants. (Courtesy of NoirTech Research, Inc.)

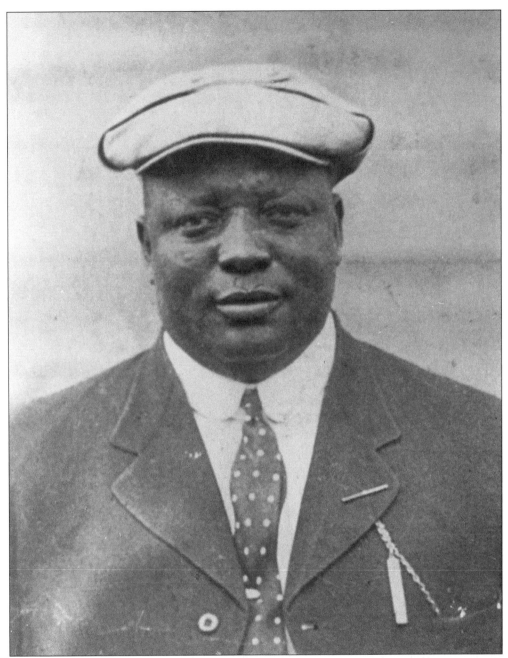

Although some histories list Tenny Blount as the owner of the Detroit Stars from 1919 to 1925, the team's true owner was Rube Foster. The founder and president of the Negro National League, Foster hired Blount to operate the team but kept the true power of ownership. The most accurate description of Blount's position, in today's baseball vernacular, would be general manager. (Courtesy of National Baseball Hall of Fame.)

One of early black baseball's best players and biggest stars was Joseph Preston "Pete" Hill. Hill became a player/manager for the Detroit Stars in 1919 after learning the art from the legendary Rube Foster. Hill remained in control through the end of the 1921 season. That year, at the age of 41, he compiled a season batting average of .391. (Courtesy of Dick Clark.)

Taking his turn at bat is Pete Hill, who played with Detroit from 1919 to 1921. A great all-around player, Hill was a superb defensive outfielder and an excellent hitter who rarely struck out. A lifetime .326 hitter in the Negro Leagues, Hill set a mark that will probably never be broken when, in 1911, he got a base hit in 115 of 116 games. He was not only a terror for opposing pitchers at the plate, but also on the bases. Just as Jackie Robinson would do decades later, the speedy Hill would agitate pitchers with gyrations around the bag, faking like he was going to take an extra base on every pitch. After retiring from professional baseball, Hill worked for the local Ford Motor Company. (Courtesy of Chicago Historical Society.)

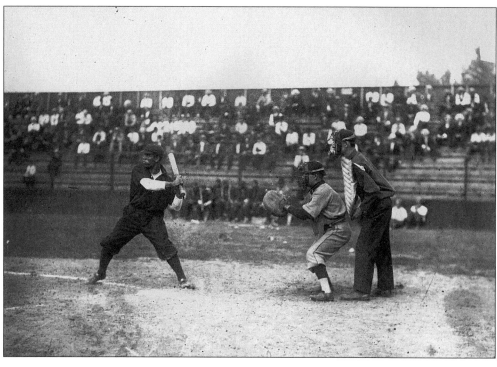

Pitcher Sam Crawford played for the Stars in 1919. One of black baseball's greatest hurlers in the 1910s, Crawford had a stealthy fastball and a floating butterfly knuckleball. During his career, which spanned 1910–1938, Crawford occasionally played a little second base and outfield. (Courtesy of NoirTech Research, Inc.)

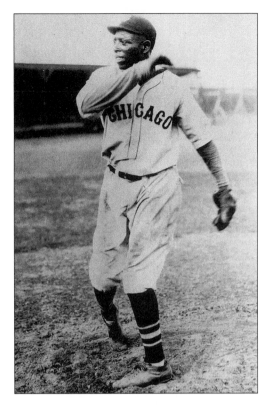

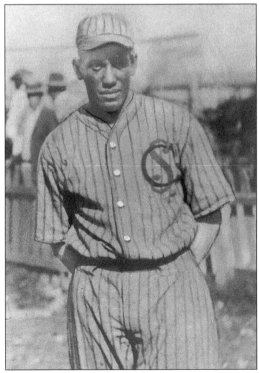

One of the finest third basemen to ever play the game, Oliver "Ghost" Marcell played for the Stars in 1919. An exceptional fielder with good speed, Marcell could cover vast amounts of territory, and would charge line drives just as he would bunts. A lifetime .305 hitter, Marcell was voted the greatest third baseman in Negro League history by the Pittsburgh Courier's experts in 1952. (Courtesy of Rick Morris.)

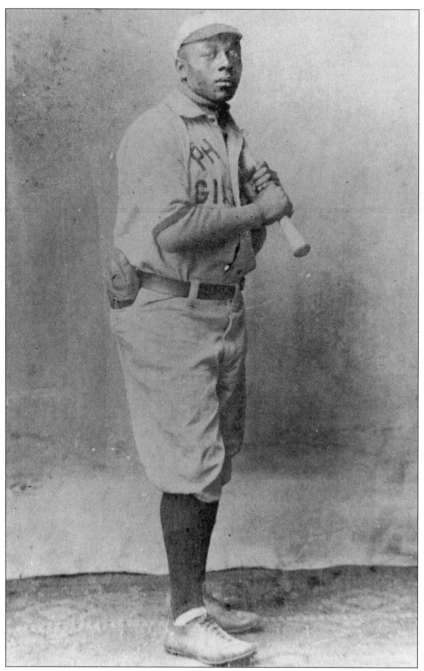

Another member of the 1919 Stars was Frank "Pete" Duncan. His calling began in 1908 with the Philadelphia Giants. The nifty, speedy outfielder was regarded as a very fine hitter with exceptional speed. He was the leadoff batter for many teams including the Leland Giants and the Chicago American Giants. In 1919, Rube Foster sent Duncan and Pete Hill to his Detroit team for league parity. The revamped Stars led by Duncan defeated Rube's American Giants with regularity that season. (Courtesy of NoirTech Research, Inc.)

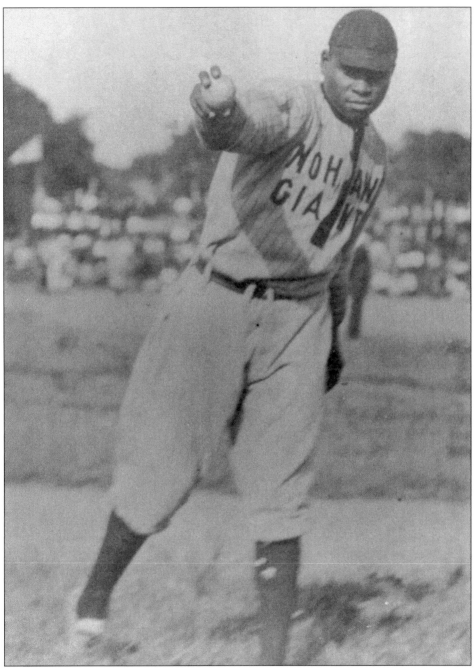

Frank Wickware was called "The Red Ant," "Big Red," and " Smiley." A scout called him "the most sensational pitcher seen for some time." And he was! The fireballer pitched several no-hitters. As he and Hall of Famer Walter "Big Train" Johnson shared the same hometown of Coffeyville, KS, he faced the "Train" in three games and beat him twice. Wickware pitched from 1910 through 1925. His sole appearance in Detroit was in 1919. (Courtesy of Frank Keetz.)

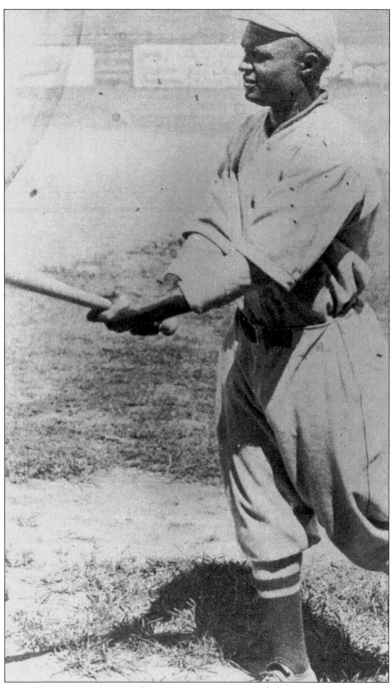

A toy cannon, the diminutive Hurley McNair was one of the game's greatest home run hitters. McNair had a reputation as the league's best two-strike hitter. According to teammate George Giles, "Mac could have taken two strikes on Jesus Christ and base-hit the next pitch." The little man with the big bang played from 1912 to 1937, and often led his club in homers. He played for Detroit clubs in 1919 and 1928. (Courtesy of NoirTech Research, Inc.)

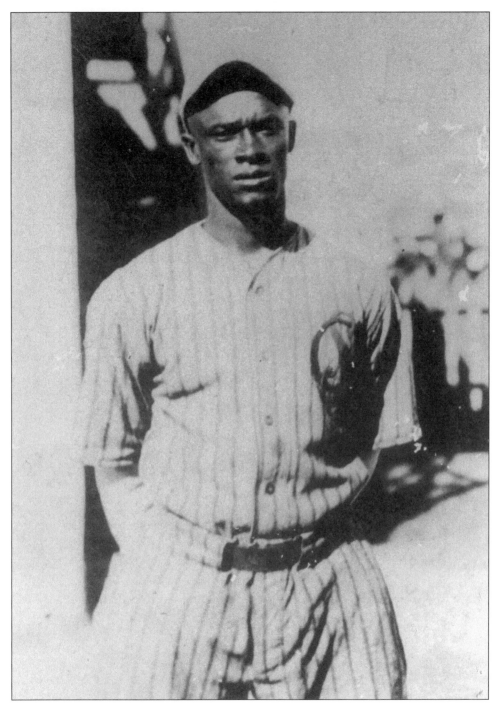

A highly talented second baseman and good hitter, Frank Warfield played with the Stars from 1919 through 1922. He had a reputation of being overly competitive and even downright nasty at times. Nonetheless, he was an asset to any team he played on. Unfortunately, Warfield is best remembered as the man who bit off part of teammate Oliver "Ghost" Marcell's nose in a 1930 fight. (Courtesy of Rick Morris.)

The Pittsburgh Inn, located at 3825 St. Antoine, shown here on July 26, 1920, was a popular dining place among Negro League players visiting the city. It offered good food at very reasonable prices. You could get a steak for 50¢, a slice of pie for a dime, and steaming hot coffee and tea were served at no charge. (Courtesy of Richard Bak.)

Two

THE RENAISSANCE YEARS
1920–1928

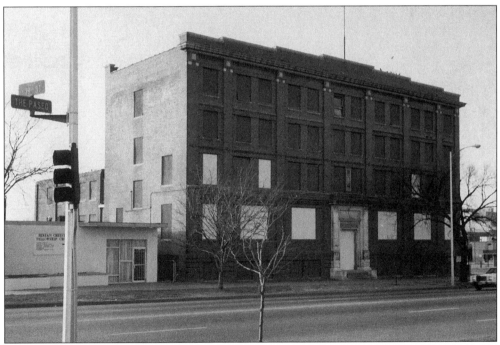

After preliminary meetings held in Chicago and Detroit, creation of the the Negro National League was finalized at a meeting in Kansas City, MO, at the Paseo YMCA (shown here in 1995) on 18th Street and the Paseo. On the eighth day, February 13, 1920, the league was officially formed. Team representatives from the Detroit Stars, the Chicago American Giants, the Cuban Stars, the Chicago Giants, the Indianapolis ABC's, the Dayton Marcos, the Kansas City Monarchs, and the St. Louis Giants signed the corporate charter. (Courtesy of NoirTech Research, Inc.)

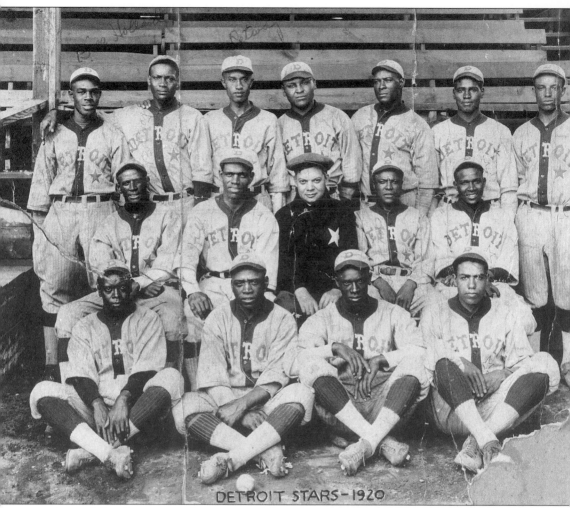

DETROIT STARS—1920

One of the charter member teams of the Negro National League was the Detroit Stars. Pictured here is the 1920 team. They are as follows, from left to right: (front row) unidentified, William Force, Orville Riggins, and unidentified; (middle row) Buck Hewitt, Pete Hill, Tenny Blount (owner), Jimmy Lyons, and Andy Cooper; (back row) Bill Holland, Edgar Wesley, Bruce Petway, Charlie Harper, Bill Gatewood, unidentified, and unidentified. (Courtesy of NoirTech Research, Inc.)

A master of the spitball and emery ball, "Big Bill" Gatewood played for the Detroit Stars in 1920 and 1921. He also appeared as a first baseman and outfielder as well as a manager during his career, but Gatewood's lasting fame was found on the mound. In 1921 Gatewood hurled a no-hitter. He would go on to become tutor of the legendary Leroy "Satchel" Paige. (Courtesy of Chicago Historical Society.)

From 1920 through 1927 and again in 1930, the Stars' staff included one of the game's greatest pitchers, Andy "Lefty" Cooper, shown here in his Havana Reds uniform. With 123 official league victories, Cooper ranks second on the all-time wins list behind only Hall of Famer Willie Foster. The six-foot two-inch, 220-pound Cooper had exceptional control and a vast array of pitches that secured him the role of pitching staff ace during his tenure in the Motor City. Cooper compiled a record of 92 wins and 47 losses with the Stars. (Courtesy of NoirTech Research, Inc.)

31

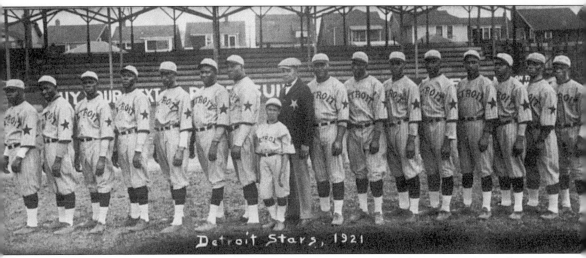

Detroit Stars, 1921

The 1921 Stars pose inside Mack Park, the team's home field from 1920 through 1929. This version of the Stars finished in fourth place in the Negro National League with a record of 32 wins and 32 losses. Players with Cooperstown credentials are Bruce Petway (fifth from left) and Pete Hill (second from right). The man in the sweater, (middle of picture) was "numbers" banker John "Tenny" Blount. Similar to today's state lotteries, the then-illegal numbers games were popular in black communities. (Courtesy of Richard Bak.)

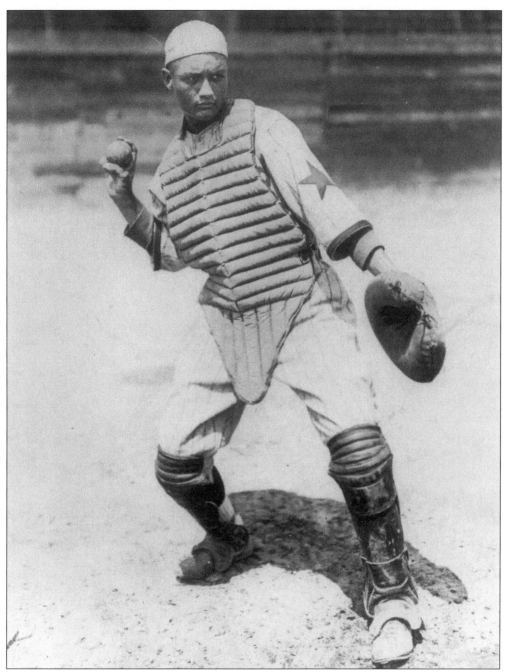

Catcher Leon "Pepper" Daniels played for the Stars from 1921 through 1930. While Daniels was only a fair hitter, usually having averages in the .250 to .260 range, he was an excellent defensive catcher. He was once spiked by Indy ABC's player Gerard Williams in a collision at home plate. Daniels was cut on his left arm, left leg, and jaw. As expected, both benches emptied as the brawl was on. (Courtesy of Leon T. Daniels Jr.)

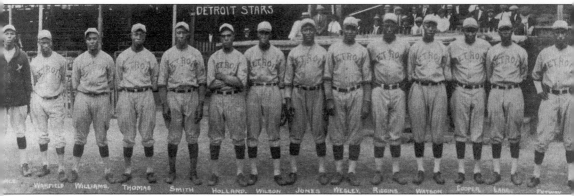

Pictured are the 1922 Stars. They are, from left to right, Bill Force, Frank Warfield, Poindexter Williams, Clint Thomas, Clarence Smith, Bill Holland, Charles Wilson, John Jones, Edgar Wesley, Orville Riggins, John Watson, Andy Cooper, I.S. Lane, Bruce Petway, and the team mascot Johnnie. They finished the season in fifth place with a record of 45 wins and 32 losses. Cooper pitched four shutouts that season, a club record. (Courtesy of *Kansas City Call*.)

Bruce Petway (left) with Johnnie, the team's mascot, joined the Stars in 1919 and was player/manager of the team from 1922 through the 1925 season. One of black baseball's greatest catchers, the Tennessee-born Petway gained immortality in baseball annals, when, during a 1910 exhibition game, he threw out future Hall of Famer and Detroit Tiger Ty Cobb twice in steal attempts. Petway was surprisingly fast for a catcher and was an excellent base stealer and proficient bunter, but had little power. At times, Petway excelled at the plate, hitting .341 in 1924, but at other times couldn't buy a hit, hitting only .182 in 1925. Under his guidance, the Stars won the Western Championship in 1919, and finished second in the Negro National League in 1920 and 1923. Petway's last year in professional baseball was 1925. Afterwards he managed an apartment complex in Chicago, where he died in 1941. (Courtesy of Richard Bak.)

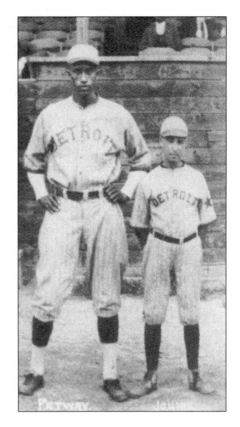

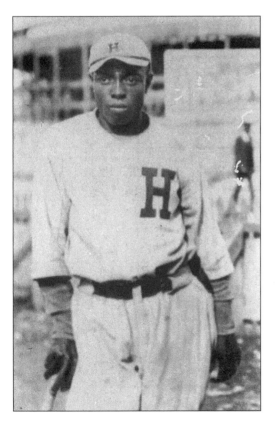

Clint Thomas, one the Negro Leagues most talented "ballhawks," played for the Stars in 1922. An all-around player, Thomas could hit for both high average and swing for the fences. He was a master defensive center fielder and was infamous for his larceny on the basepaths. A shortstop prior to coming to Detroit, Thomas switched to the outfield and responded by hitting .342 for the season. During the off season, Thomas worked for the Ford Motor Company on the assembly line. (Courtesy of NoirTech Research, Inc.)

35

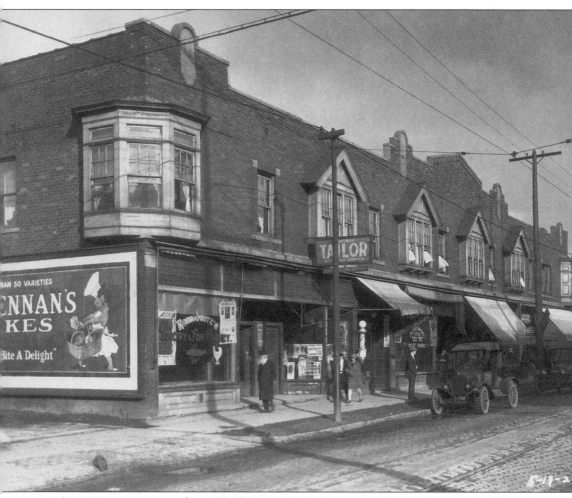

This 1922 street scene from Black Bottom's business area shows how well defined the split between the white and black communities was, as illustrated by the billboard at the left. Unlike today, when companies use both blacks and whites in the same advertisements, this ad directly targeted Detroit's black community. Brennan's Cakes were available throughout the city, but only in Black Bottom was the image of a black woman seen. (Courtesy of Manning Brothers.)

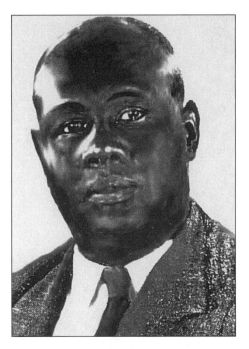

Henderson "Ben" Turpin was the most well known and respected black policeman to ever walk a beat in Paradise Valley and Black Bottom. Turpin, originally from Kentucky, became a police officer on August 11, 1927. He was renowned for the pearl-handled revolvers he carried when walking his beat. He was assigned to the city's third precinct located on Gratiot Avenue, and served 25 years. (Courtesy of Richard Bak.)

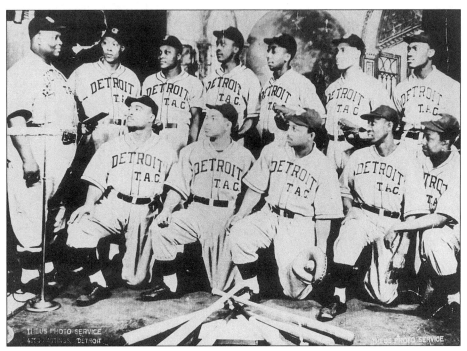

Ben Turpin (standing at left) was a great fan of the Detroit Stars. Former Star Saul Davis remembered that "he was a character" and that "he really liked his sports." He liked his sports so well he formed his own baseball team—Turpin's Athletic Club, or simply T.A.C. (Courtesy of Richard Bak.)

To many white Detroit residents in the 1920s, the black Detroit Stars were as much their team as the white Detroit Tigers were. Although the majority of the fans at Negro League games were black, a number of whites also attended. Most of the whites that attended games were like Carlon Clark, pictured here, who had played against black players in Tennessee before moving to Detroit. Clark lived near Mack Park. The fact that quality baseball was nearby was more important than the color of the players. (Courtesy of Dick Clark.)

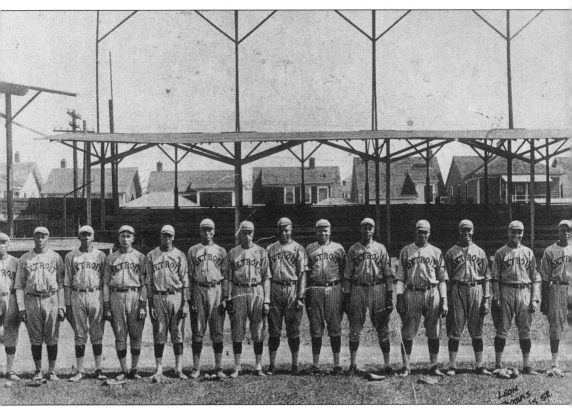

The 1923 Stars finished second to the Kansas City Monarchs in the race for the Negro National League pennant. Some of their top players included Turkey Stearnes (sixth from left), Bruce Petway (seventh from left), and Andy Cooper (ninth from left). Cooper holds the club record for the most career starts, games won, and shutouts. He owned more records than Motown's Berry Gordy. (Courtesy of Leon T. Daniels Jr.)

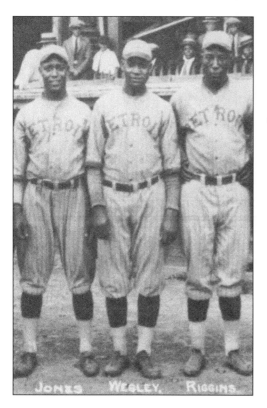

Second baseman John Jones (left), first baseman Edgar Wesley (center), and shortstop Orville Riggins (right) were all members of the Detroit Stars infield. All three were fine defensive players and could hit for both power and average. Jones was with the Stars from 1922 to 1929, Riggins from 1920 to 1926, and Wesley played with the Stars from 1919 to 1923 and from 1925 to 1927, and was the Stars' first legitimate power hitter before Turkey Stearnes arrived. (Courtesy of Richard Bak.)

This ad appeared in the National Amateur Baseball Federation Program in 1924. Due to the fact that Negro League teams were not part of white "organized" baseball, they were able to take part in semi-pro leagues or tournaments while at the same time being members of, in the Stars' case, the Negro National League. The results of these arrangements were predictable, with the Negro League teams taking the championships on a regular basis. (Courtesy of Dick Clark.)

Compliments of

DETROIT STARS

Michigan Semi-Pro.
Champions

1919-20-21-22-23

J. TENNY BLOUNT, President

Sporting the fashionable knickers and apple caps of the day are a trio of second basemen—Newt Allen (left), Grady Orange (center), and Bob Fagan (right). Fagan, a "second sacker" for the Kansas City Monarchs in the early twenties, never played for a Detroit team. Slick-fielding Allen appeared with the Detroit Wolves in 1932, their only season, while Orange played for the Detroit Stars for three-and-a-half years. This picture was taken in the mid-twenties. (Courtesy of Barbara Orange-Jones.)

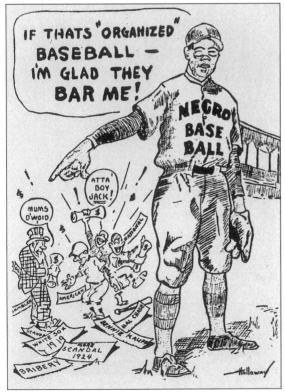

This cartoon appeared in the nationally distributed *Pittsburgh Courier* in 1924. While organized black baseball was not perfect, the black press fought hard to correct the problems. Tabloids like the *Courier*, the *Chicago Defender*, and the *Michigan Chronicle* regularly featured articles detailing how fans should dress and behave at games, as well as lists of "do's and don'ts." The intent was for the Negro League teams and their fans to respect the games, while employing the highest level of decorum. (Courtesy of Richard Bak.)

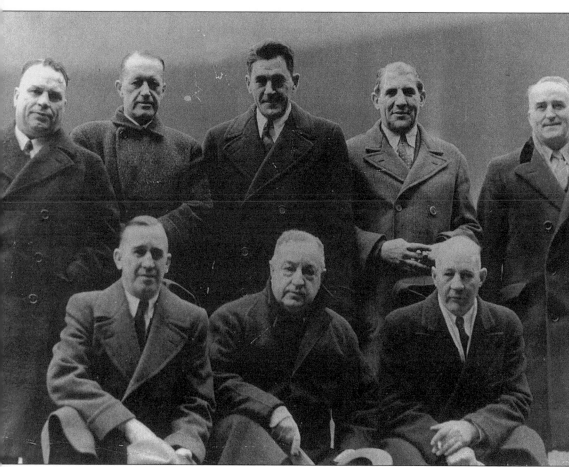

A Dutch Jewish haberdasher, John Roesink (front row, middle) owned the Detroit Stars from 1925 to 1930. In addition to the team, Roesink owned Mack Park, Hamtramck Stadium, and three stores in downtown Detroit. The second white owner in the Negro National League (after J.L. Wilkinson), Roesink was looked upon as one of the league's best owners by the players, and as a gentleman by the residents of Black Bottom. (Courtesy of Richard Bak.)

On September 8, 1925, Detroit dentist Ossian Sweet and his family moved into a home at 2905 Garland, seven blocks south of the Detroit Stars' home at Mack Park. Reflective of the times, Sweet's new white neighbors were less than pleased. The first night a mob gathered around the home and began to hurl rocks through the windows of the house. When it appeared that the mob was about to storm the house, shots were fired from inside, killing one white intruder and injuring another. Sweet and his brother were arrested and arraigned for murder. The NAACP came out in support of the Sweets and hired the services of legendary attorney Clarence Darrow, who won the case with an eight-hour closing argument. (Courtesy of Richard Bak.)

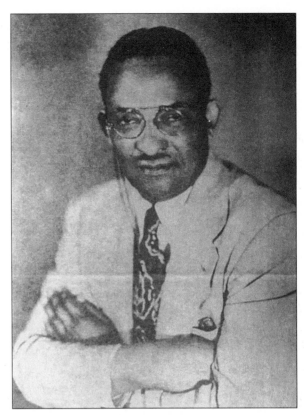

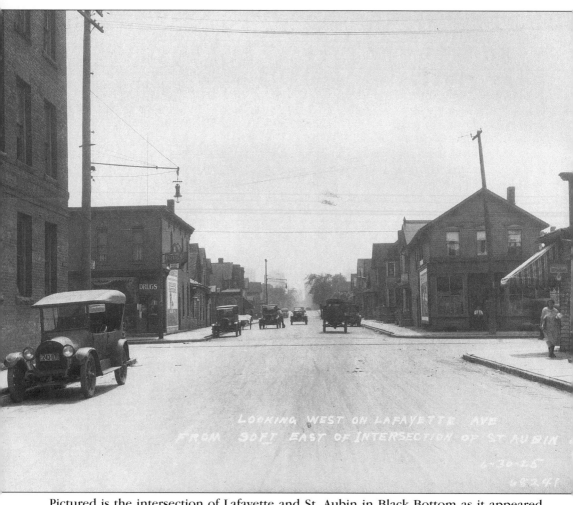

Pictured is the intersection of Lafayette and St. Aubin in Black Bottom as it appeared on June 30, 1925. According to author Richard Bak in his book *Turkey Stearnes and the Detroit Stars*, "the red hot Stars were playing at home that afternoon against the Indianapolis ABCs, which may account in part for the relatively empty sidewalks." (Courtesy of Richard Bak.)

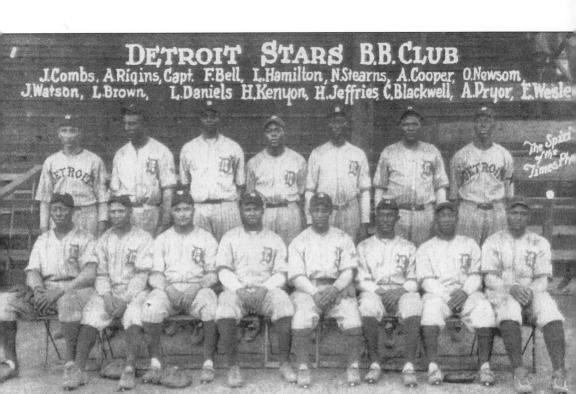

The 1926 Detroit Stars consisted of the following, from left to right: (front row) Johnny Watson, Larry Brown, Leon Daniels, Harry Kenyon, Harry Jeffries, Charles Blackwell, Anderson Pryor, and Edgar Wesley; (back row) Jack Combs, manager Orville Riggins, Fred Bell, Lewis Hampton (not Hamilton), Norman Stearnes, Andy Cooper, and Omer Newsome. The team finished in fourth place with a record of 53 wins and 46 losses. (Courtesy of Dick Clark.)

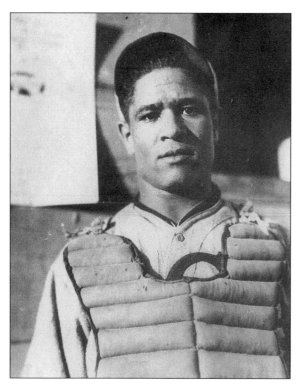

One of the finest defensive catchers in baseball, black or white, was Larry "Ironman" Brown, who played with the Detroit Stars in 1926. Brown was a light hitter, with a lifetime .260 batting average, but an excellent handler of pitchers. He also had a powerful and accurate arm when it came to throwing out those attempting larceny on the basepaths. Legend has it that the light-skinned, Spanish-speaking, Alabama-born Brown so impressed certain major league representatives that they tried to talk Brown into passing as a Cuban, thus getting around the unwritten color barrier in the majors. According to reports, Brown refused, saying that if he couldn't go to the majors as Larry Brown, he wouldn't go at all. (Courtesy of NoirTech Research, Inc.)

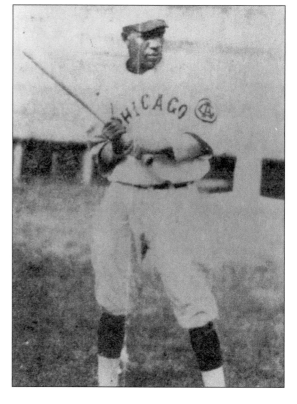

Although Elwood "Bingo" DeMoss is best known as the greatest second baseman in Chicago American Giants history, he managed five Detroit teams. His Stars in 1927 had a 53–46 record for fifth place, in 1928 a 54–37 record for second place, in 1929 they were 38–42 for fourth place, in 1930 they finished second with a 50–33 record, and they fell to fourth place in 1931 with a 32–36 record. (Courtesy of Dick Clark.)

After spending his rookie season with the champion Kansas City Monarchs, Harold "Yellowhorse" Morris joined the Stars in 1925 and stayed for four seasons. They called him Yellowhorse because of his "hi' yella" complexion and his Native-American heritage. In Morris' first year as a Star, he compiled an 8–2 record. His most productive season came in 1927 when he won 14 games, with three shutouts, against eight losses. (Courtesy of NoirTech Research, Inc.)

Claude "Hooks" Johnson started his pro career in 1919 with the Brooklyn Royal Giants. For the next 12 years, he patrolled the infield for several teams, including the Cleveland Tate Stars, Harrisburg Giants, Birmingham Black Barons, Memphis Red Sox, Nashville Elite Giants, and the Pittsburgh Crawfords. Johnson played second base for the Detroit Stars from 1927 to 1929. (Courtesy of NoirTech Research, Inc.)

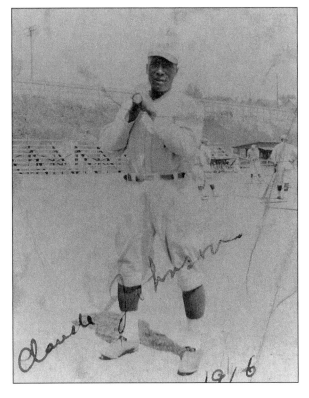

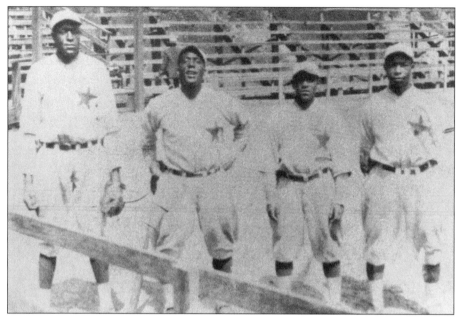

Pictured are Detroit Stars teammates Ed "Huck" Rile (at left) and Wade Johnston (far right), with two unidentified players. Rile was with the Stars from 1927 to 1930. During his first year he pitched and played first base, hitting .401 with 10 home runs in 68 games. On July 11 of that year, he pitched (and won) both games of a double header against the Kansas City Monarchs. (Courtesy of Minnie Johnston Martin.)

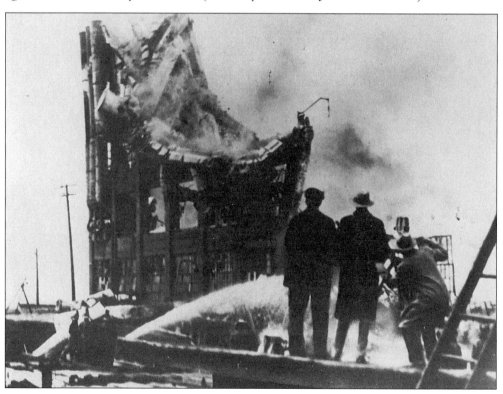

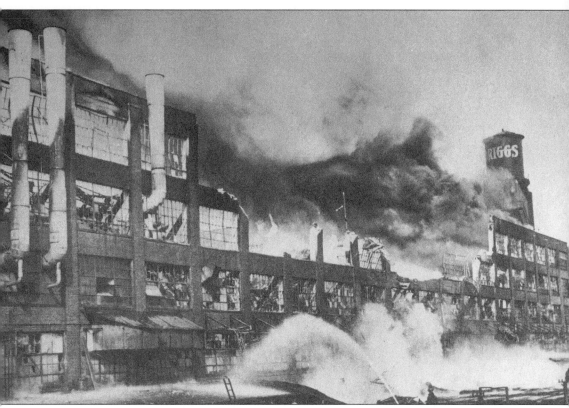

Known in Detroit as "Briggs' Slaughterhouse" due to hazardous working conditions, the auto body plant owned by Walter O. Briggs exploded on April 23, 1927 (pictured above and opposite below). The factory, located at Harper and Russell Streets, burned for two days, resulting in 21 fatalities. On the day before the explosion, Turkey Stearnes and roughly 12 other Stars quit their jobs at the plant and left for spring training in New Orleans, LA. (Courtesy of Richard Bak.)

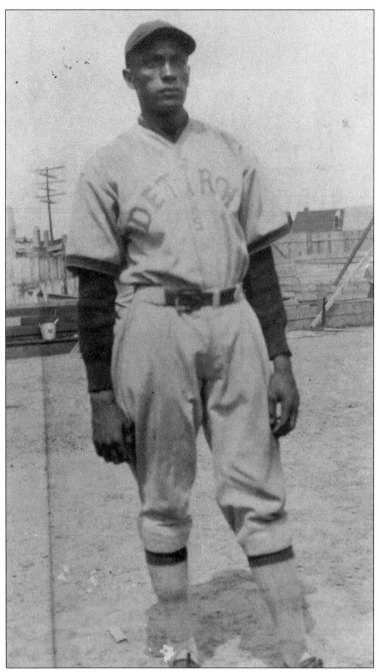

Dallas-native Dr. Grady Diploma Orange, nicknamed "The Texas Flash," was a teacher in the off season. His Negro League career stretched from 1925 to 1931. He played shortstop, second base, and third base for the Detroit Stars from 1928 to 1931. He could play every position except catcher and pitcher. Orange graduated from Meharry Medical College in 1931 with the highest four-year GPA in school history. Christened with the middle name of Diploma at birth, education was a high priority with his parents. (Courtesy of Barbara Orange-Grady.)

Three
THE DEPRESSION YEARS
1929–1931

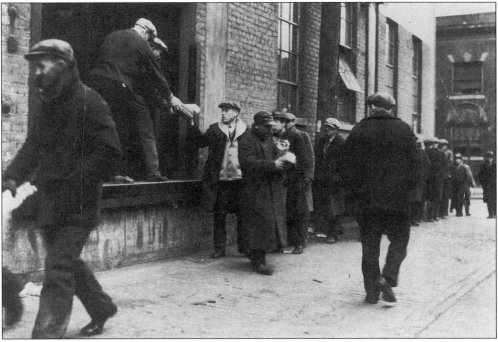

Bread lines like these were commonplace in major cities after the stock market crashed in 1929. The ensuing depression resulted in most Negro League teams, including the Detroit Stars, struggling to survive. The Negro National League fell victim to the country's financial woes when it collapsed three months into the 1931 season. (Courtesy of Richard Bak.)

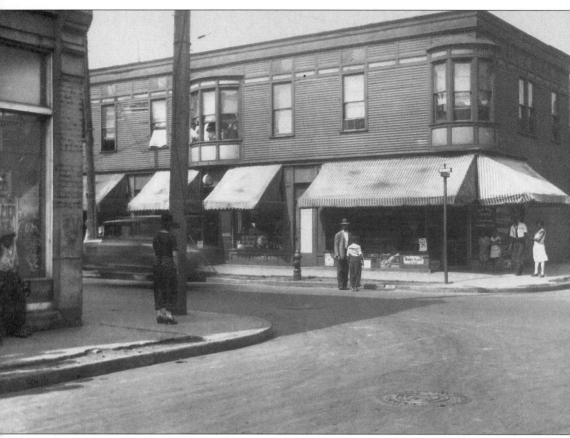

Pictured is the corner of Erskine and Rivard as it appeared in 1929. This section of Black Bottom was the home of a number of speakeasies and brothels. During Prohibition, Detroit was reportedly the home of 20,000 illegal stills. During interviews with former Negro League players, some acknowledged that players frequented this corner after happy hour. (Courtesy of Manning Brothers.)

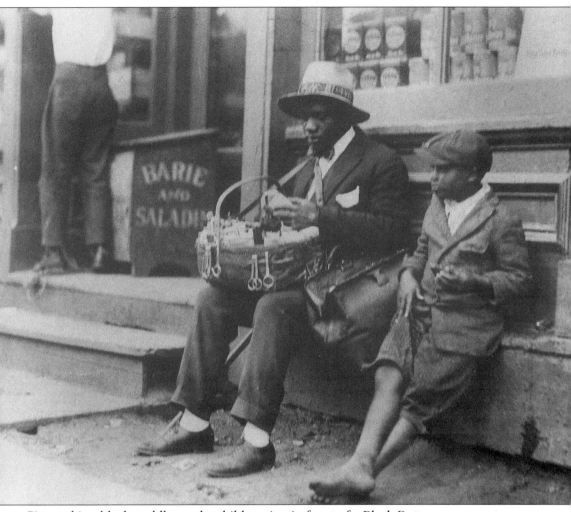

Pictured is a black peddler and a child resting in front of a Black Bottom grocery store. During the Depression, when black unemployment was rampant, individuals made money by any means necessary. Peddling small household necessities was one option. Many businesses supplied the peddler with his wares and gave him a percentage of what he sold. (Courtesy of *The Detroit News*.)

Despite the hardships and racism faced by Negro League players on a daily basis, players saw the game as an escape from the drudgery of the assembly line. Other employment options for African-Americans at the time were in factories, on farms, or as menial servants. Star players Pete Hill, Clint Thomas, and others labored many hours on lines during the off-season. (Courtesy of Manning Brothers.)

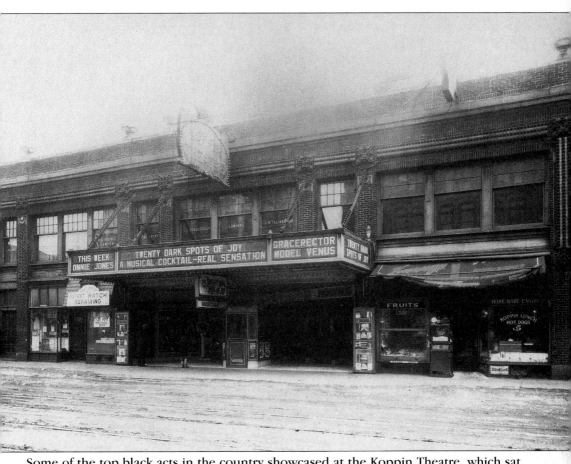

Some of the top black acts in the country showcased at the Koppin Theatre, which sat on Gratiot Avenue in Paradise Valley. Black entertainers regularly took part in Negro League games in various roles. Jazz musician Lionel Hampton was an honorary first base coach at times, while Lena Horne and B.B. King were known to perform before games. (Courtesy of Manning Brothers.)

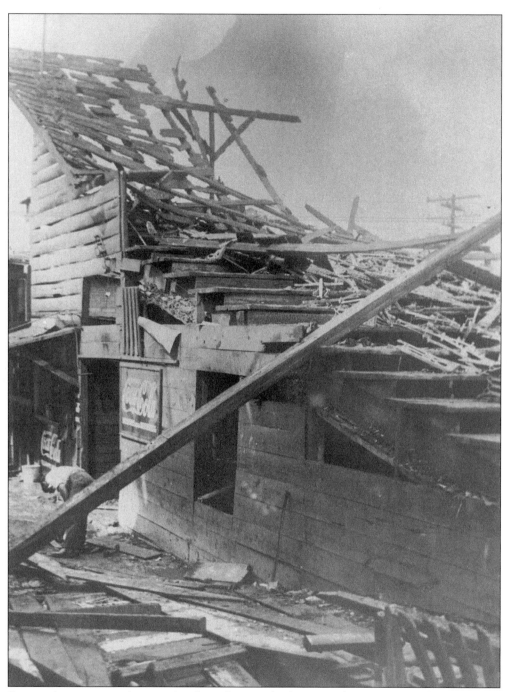

Severe damage was done at Mack Park on July 6, 1929, during a game between the Detroit Stars and the Kansas City Monarchs, when a fire erupted. The cause of the fire is believed to be gasoline, used to dry the infield, stored under the right field bleachers where the fire started. (Courtesy of *The Detroit News*.)

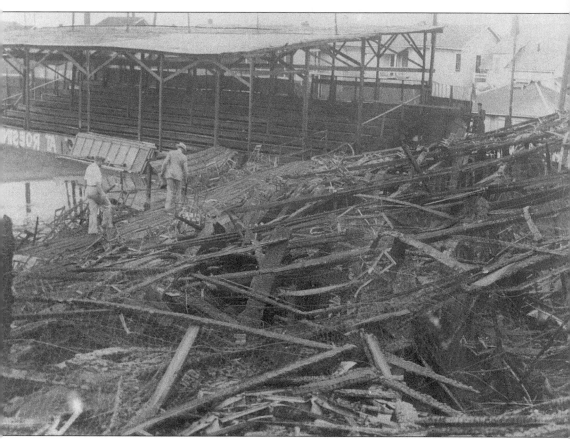

Once the fire started, players from the Stars and Monarchs began tearing down the chicken wire that surrounded the field to help people evacuate the stands. While a reported 103 people were injured, the players' actions doubtlessly saved countless other injuries, and possibly lives. The park was repaired and used well into the 1960s before it was finally torn down. (Courtesy of *The Detroit News*.)

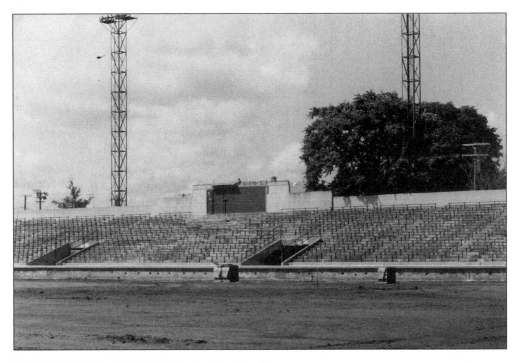

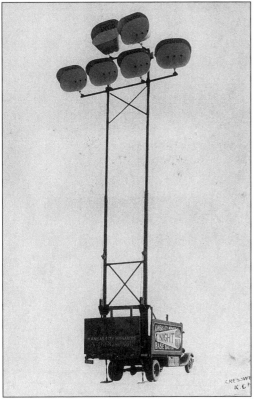

Pictured above is Keyworth Stadium (also known as Hamtramck Stadium), the sight of the first professional night game in Motown. The Stars battled the Kansas City Monarchs, under Monarchs owner J.L Wilkinson's portable lighting system, on June 28, 1930. The lights sat on telescoping poles attached to the beds of trucks. The trucks (pictured at left) were parked around the field, then wired to a loud, humming, portable generator, which ran the entire system. (Above photo courtesy of Dick Clark; photo below courtesy of Kansas University Special Collections.)

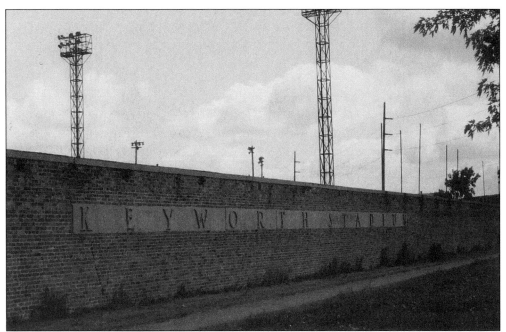

Keyworth Stadium, which is currently used as a football stadium, was the Stars' home park in 1930, 1931, and 1933. The Detroit Wolves used the park as their home field in 1932. The Calvert Coal Company bordered the north wall of the stadium and the Grand Trunk Factory railroad tracks ran between the south end of the park and the factory. (Courtesy of Dick Clark.)

The Elmwood Grill, built in the 1930s Art Deco style, as it appears today. During the early fifties the Elmwood Grill was a popular eatery in Black Bottom for black ballplayers. It offered traditional fare as well as food more popular among African Americans that had emigrated from the South. (Courtesy of Dick Clark.)

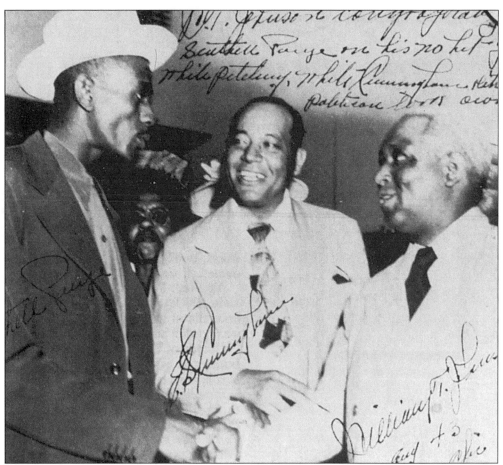

The legendary Satchel Paige (left) is greeted by William T. Johnson (right), the owner of the Horseshoe Bar. Known throughout black baseball for his love of a good time, Paige was considered an authority on hot spots in each city. An appearance by a star the caliber of Satchel Paige proved, beyond a doubt, that the Horseshoe Bar was the place to be in Paradise Valley. (Courtesy of Burton Historical Society.)

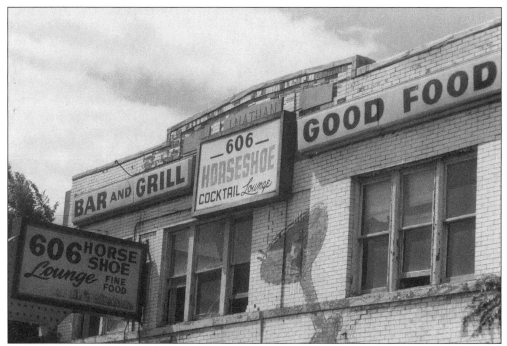

Pictured above in 1999, the Horseshoe Bar, located at 606 St. Antoine, was one of the more popular night spots in Paradise Valley during the 1930s. Patrons could expect to find a good time, good food, and good entertainment whenever they went. The Horseshoe showcased world-class musicians and world-famous patrons. (Courtesy of Dick Clark.)

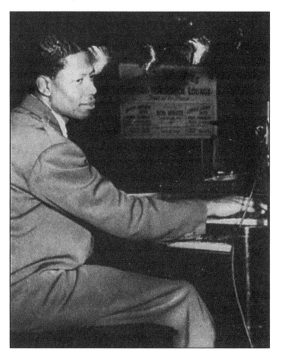

Organist Teddy Harris entertains at the Horseshoe Bar. Nightclubs such as the Horseshoe were regular stops for the top musicians of the time. The only places black bands had to showcase their talents were in small theaters or bars in surrounding black communities, known as the "chitlin' circuit." This was due to the fact that large theaters were mostly found in white areas where black patrons, and sometimes black entertainers, were not welcome. (Courtesy of Burton Historical Society.)

TRENTON PUBLIC LIBRARY

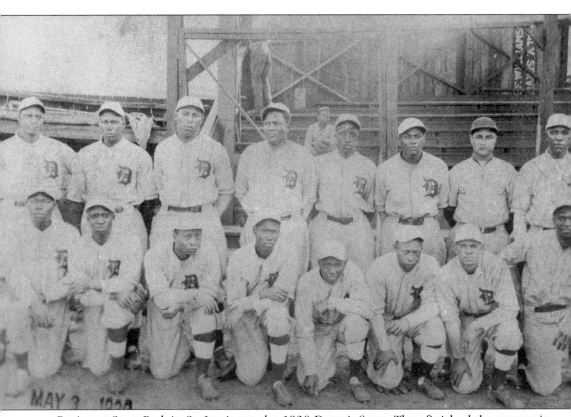

Posing at Stars Park in St. Louis are the 1930 Detroit Stars. They finished the season in second place, with a 50–33 record. The players are as follows, from left to right: (front row), Nelson Dean, Clarence "Spoony" Palm, Ted Shaw, Grady Orange, Willie Powell, Wade Johnston, Jake Dunn, and Bobby Robinson; (back row) Crush Holloway, Albert Davis, Ed Rile, Andy Cooper, William Love, Elbert Williams, Leon "Pepper" Daniels, and manager Bingo DeMoss. Not shown is the legendary Norman "Turkey" Stearnes. (Courtesy of John Holway.)

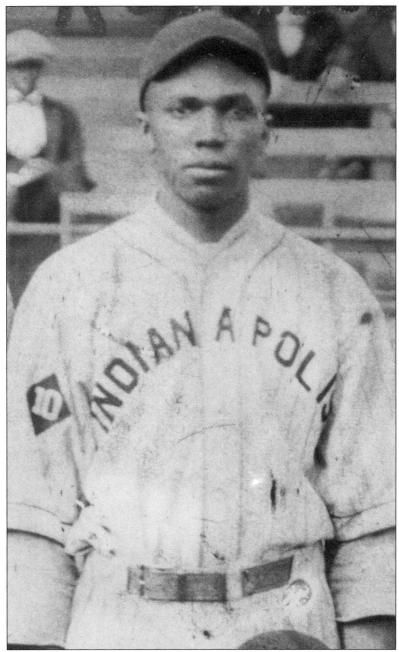

Although pictured here in an Indianapolis ABC's uniform, William "Bobby" Robinson was an integral part of several Star teams. In a 1930 game against the St. Louis Stars, Robinson initiated a triple play. "Yep, I was playing for Detroit when the greatest thing in my career happened—I started a triple play," claimed Robinson. James "Cool Papa" Bell was on third while Branch Russell was on second. Branch's brother John Henry hit a stinging liner to Robinson, who beat Bell back to the bag for the second out, and fired the ball to second to double off Branch for the trifecta. (Courtesy of Bobby Robinson.)

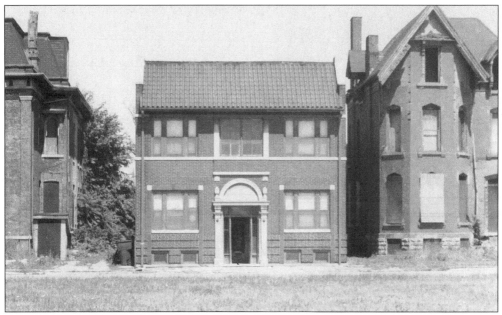

This apartment building in Black Bottom shows a dwelling typical of many of Detroit's African-American middle class citizens. Black doctors, dentists, teachers, and other professionals formed the middle class of African-American communities. Due to racial policies, blacks classified with "upper class" status were very rare. (Courtesy of Dick Clark.)

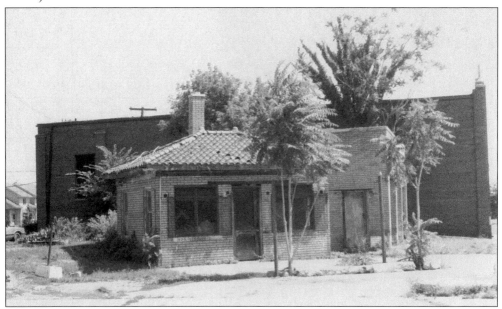

In the heyday of Paradise Valley, this Black Bottom building was a popular gas station. Negro League teams that used buses as their main mode of transportation would find the businesses that gave them the best service, and patronize them whenever in the city. Within the inner city, being able to say "the Detroit Stars buy their gas here" was guaranteed to increased revenue. (Courtesy of Dick Clark.)

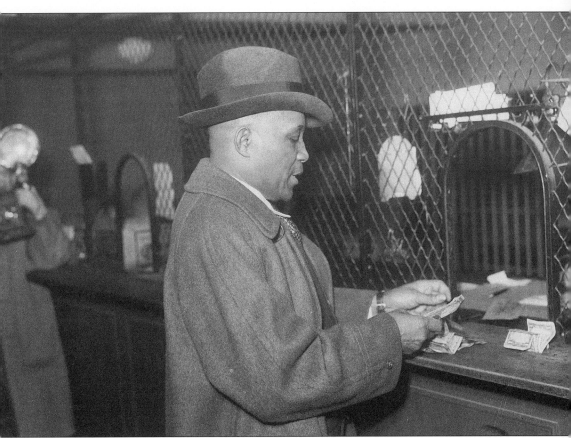

Numbers racketeer Everitt Watson owned the Detroit Stars in 1931. At that time, due to the Great Depression, the Negro National League was having trouble filling seats, and was on the verge of collapse. With Watson giving a higher than normal percentage of the ticket sales to John Roesink (owner of Hamtramck Stadium) for rental fees, he often failed to make payroll for the team. When the league folded three months into the season, Watson vanished, leaving several players broke and stranded in Detroit. (Courtesy of *The Detroit News*.)

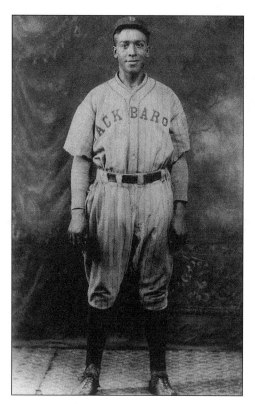

Saul "Rareback" Davis, from Little Rock, AR, was one of the most versatile infielders in the game. Davis began his career with the semi-pro Houston Black Buffaloes in 1918. Shown here as a Birmingham Black Baron in 1923, Davis closed out his playing career with the Detroit Stars in 1931. (Courtesy of National Baseball Hall of Fame.)

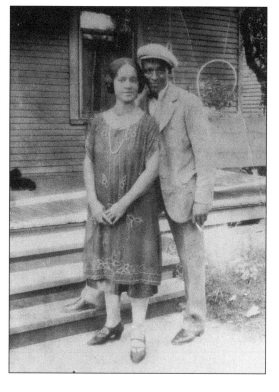

Saul Davis is pictured here in his younger days with his sister, Juanita Davis Beadle, c. 1922. Davis is often credited with discovering a young Alabama lad named Satchel Paige. Davis played for several teams including the Black House of David, Gilkerson's Union Giants, and Jack Johnson's All-Stars, before coming to the Stars in 1931. (Courtesy of Barbara Barber.)

Norman "Turkey" Stearnes hit .378 in 1929, and .340 in 1930, when he played 20 games with the New York Lincoln Giants. Financial troubles, which eventually ruined the Stars team, caused Stearnes to leave the team and join the Kansas City Monarchs. For the 1931 season, he hit .350 and won the league batting championship. (Courtesy of Dick Clark.)

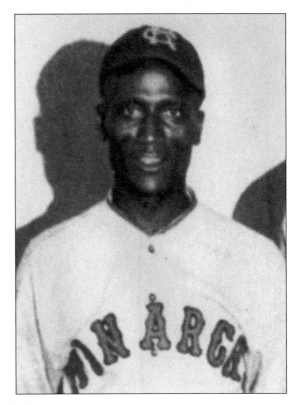

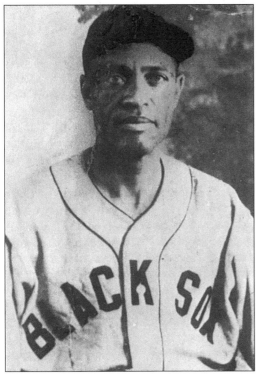

The switch-hitting Crush Holloway acquired his unique first name after his father had witnessed a train wreck on the day of his birth. Crush proudly claimed that Ty Cobb was his idol because of the way he ran the bases—"hard and with his spikes up." Crush was indeed a runaway freight train on the basepaths. The former Baltimore Black Sox player replaced the irreplaceable Turkey Stearnes in the 1930 lineup when the Turk jumped to the New York Lincoln Giants. (Courtesy of NoirTech Research, Inc.)

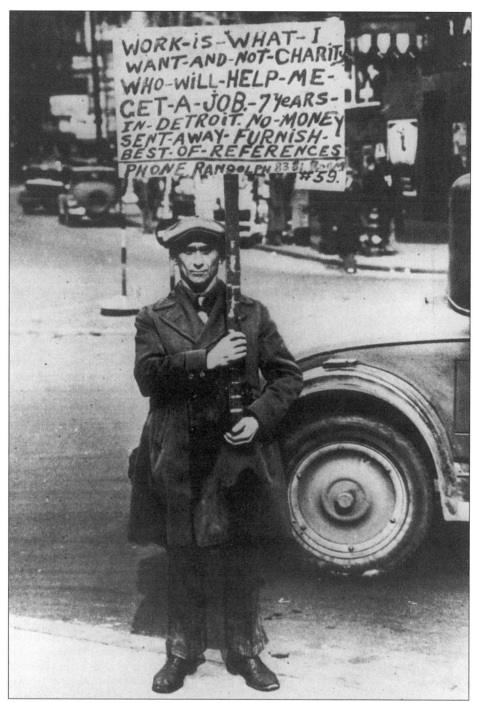

The effects that the Great Depression had on Detroit's working class can be seen here. Many business owners felt that if anyone was going to lose their job, it should be an African American, and so the black community was hit even harder than the nation's white communities. This fact is one of the reasons that the Negro National League collapsed in 1931. (Courtesy of Wayne State University.)

Four
DETROIT'S MOST TALENTED TEAM?

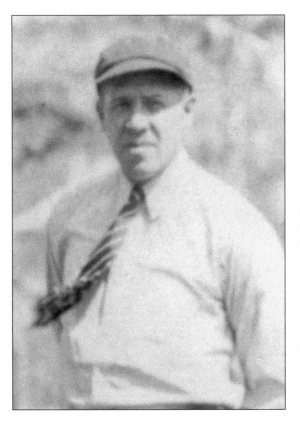

After the Detroit Stars folded in 1931, along with the Negro National League, the Motor City became home of the Detroit Wolves of the East-West League. The league was founded by Cumberland Posey, pictured here. The Wolves were made up of some of the game's greatest black players and was the league's premier team. Part way through the season, Posey combined the Wolves with his other team, the famed Homestead Grays. The new team played under the Grays' name and finished out the Wolves schedule. (Courtesy of NoirTech Research, Inc.)

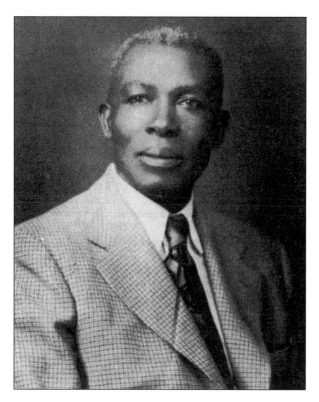

Pictured in street clothes is William "Dizzy" Dismukes, who managed the 1932 Detroit Wolves and the 1947 version of the Wolves. The '32 Wolves were leading the league when it disbanded in July. A former submarine pitcher, Dismukes is remembered as being one of the finest pitchers in baseball in the 1910s and the early part of the 1920s. Dismukes is credited with two no-hitters. He later scouted for the New York Yankees and the Chicago White Sox in the fifties. (Courtesy of NoirTech Research, Inc.)

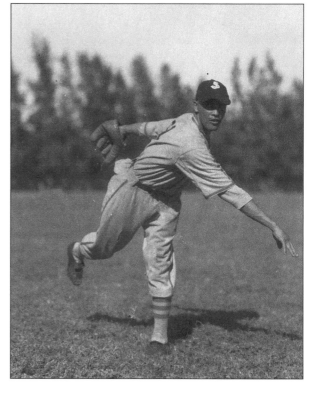

One of the best pitchers to ever play Negro League baseball was right hander Ray Brown, who was with Cumberland Posey's Wolves in 1932. Married to Posey's daughter Ethel, Brown is fifth on the lifetime list of wins with 109. He lost only 30 for a winning percentage of .762. Brown had a variety of pitches in his arsenal, but his best pitch was his curveball, which he would throw on any pitch count. (Courtesy of Luis Alvelo.)

A talented catcher and powerful switch hitter, Quincy Trouppe played for the Wolves in 1932. A lifetime .300 hitter in the Negro Leagues, Trouppe appeared in eight East-West All-Star games. In 1952, Trouppe became the first African-American catcher in the American League when he signed with the Cleveland Indians. Past his prime, he appeared in only six major league games. (Courtesy of NoirTech Research, Inc.)

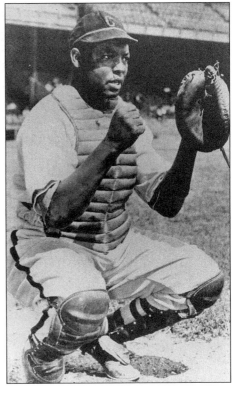

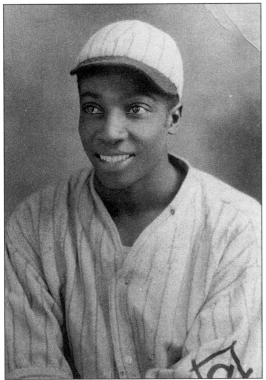

Hall of Fame member James Thomas "Cool Papa" Bell became part of Detroit baseball history when he joined the Wolves. The fastest man to ever play the game of baseball, Bell was once clocked running the bases, from home to home, a distance of 120 yards, in 12 seconds flat. Bell's other fleet-footed feats included regularly stealing two bases on one pitch, scoring from second on a sacrifice fly, and even, on one occasion, scoring from first on a bunt. When it came to playing the field against Bell, his former teammate Ted Radcliffe expressed it best by saying, "If he bunts and the ball bounces twice, put it in your pocket." In addition to his speed, Bell was a talented outfielder and threat at the plate, sporting about a .340 lifetime batting average. (Courtesy of NoirTech Research, Inc.)

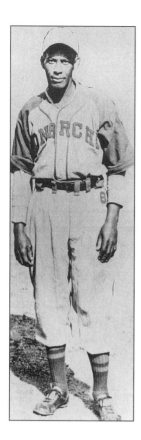

Newt "Colt" Allen played on the celebrated 1932 Wolves team that devoured the competition. He batted a respectable .300. Considered by many historians as one of the best "second sackers" in the league, Allen returned to the Kansas City Monarchs where he spent the remaining days of his career. A Hall of Fame quality infielder with a clutch stick, he often played with a flower stem between his teeth for good luck. (Courtesy of NoirTech Research, Inc.)

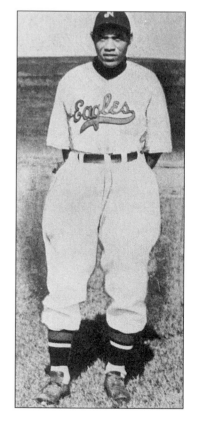

Perhaps the greatest shortstop in black baseball to follow John Henry "Pop" Lloyd was Willie "The Devil" Wells. This future Hall of Famer made his only appearance for a Detroit team in 1932. The Devil batted .296 in 16 games. He led the Wolves in doubles and stolen bases that season. A superstar in every regard, he could hit, field, and run. Wells played for several teams including the St. Louis Stars and the Newark Eagles (pictured). (Courtesy of NoirTech Research, Inc.)

Vic Harris played outfield for the Wolves. In 11 games the slap hitter belted .409 in 44 at bats, second highest on the club to catcher T.J. Young's .415 average. An outstanding lead-off hitter with excellent speed, the left-handed Harris appeared in seven East-West All-Star games. He was a mainstay with the Homestead Grays out of Pittsburgh, later managing the Grays to seven Negro National League pennants. (Courtesy of NoirTech Research, Inc.)

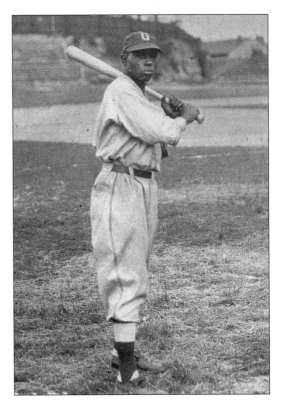

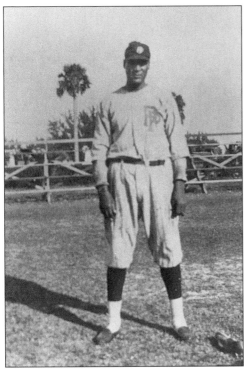

Often considered the greatest pitcher in Negro League history, Smokey Joe Williams, a half-Native American, half-African American hurler, played for the Wolves in 1932. Williams, who was inducted into the Hall of Fame in 1999, defeated seven future Hall of Fame pitchers during his career and won a record 19 games against major league all-star teams. (Courtesy of Jeff Eastland.)

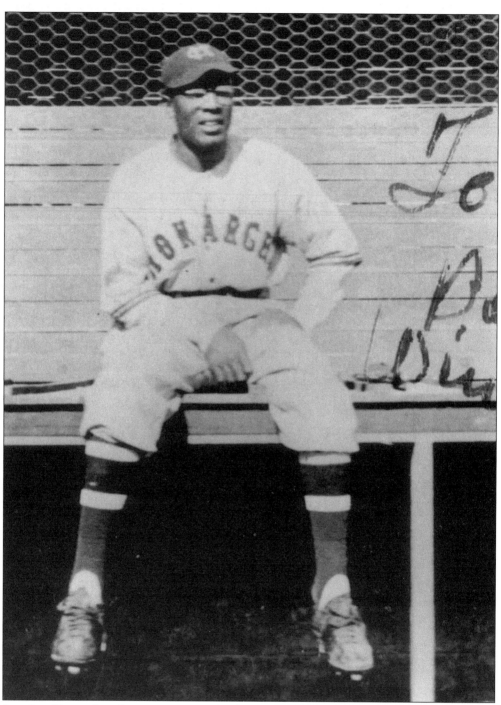

Another Monarch refugee was Leroy Taylor, one of a few bespectacled players in the league. The "flyhawk" made a brief appearance for the Wolves in 1932, and later the Stars in 1933. He was known as a skilled bunter, proficient in executing the hit-and-run, and a feared base-stealer. The Wiley College (Texas) alumni closed out his career with the Cleveland Red Sox in 1934. (Courtesy of NoirTech Research, Inc.)

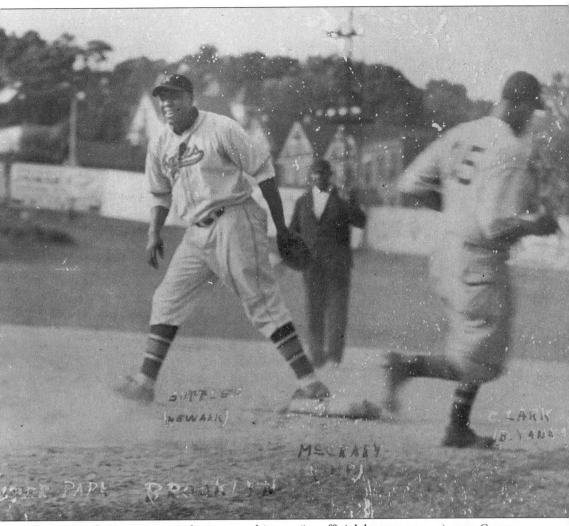

The king of Negro League home run hitters (in official league games) was George "Mule" Suttles, who hit 190 in his career. In 1932 the mighty Mule brought his 50-ounce bat to Motown as a member of the Wolves. Suttles is credited with hitting a 600-foot home run in Havana, Cuba, and according to Hall of Famer Buck Leonard, the Mule hit one out of Hamtramck Stadium. (Courtesy of National Baseball Hall of Fame.)

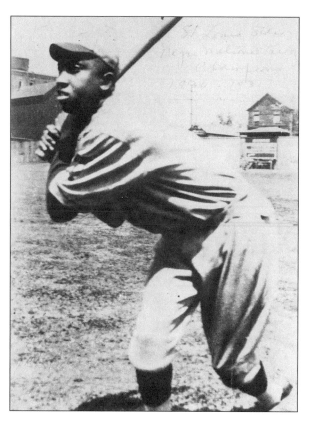

Another member of the famed '32 Wolves was George Giles, a splendid first baseman. Giles hit .348 for the team. He was known for his fancy play around the first base bag. The line-drive contact hitter normally batted second in the lineup. A lifetime .300 batter, he passed his athletic genes to his grandson Brian, who played for several major league teams in the 1980s. (Courtesy of NoirTech Research, Inc.)

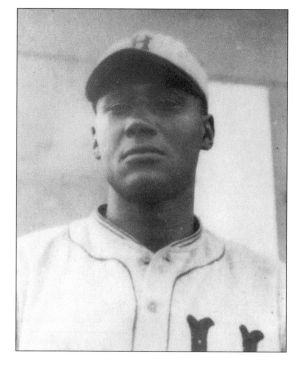

An active fastball, nice curve ball, and pinpoint control made William Bell, who played for the '32 team, a valuable commodity for any team he played for, and a danger to any team he played against. In addition to being a good hitter, Bell was a fine teacher, imparting his pitching wisdom to many up-and-coming hurlers as manager of the Newark Eagles in 1936–1937. (Courtesy of NoirTech Research, Inc.)

Five

THE LEAN YEARS
1933–1960

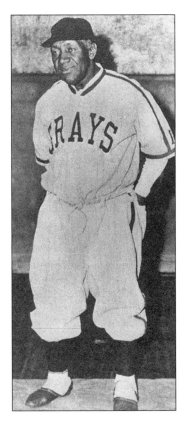

"Candy Jim" Taylor managed the 1933 Detroit Stars.
The Stars had replaced the Indianapolis ABC's in May,
and finished the first half of the season with a 13–20
record. The second-half schedule was never
completed as the league folded. Unlike most players
of his day who chewed a little Red Man tobacco, he
gnawed on candy. With the sweet tooth of
Snagglepuss, and the sternness of a stepfather, Candy
Jim is considered one of black baseball's most colorful
managers. (Courtesy of NoirTech Research, Inc.)

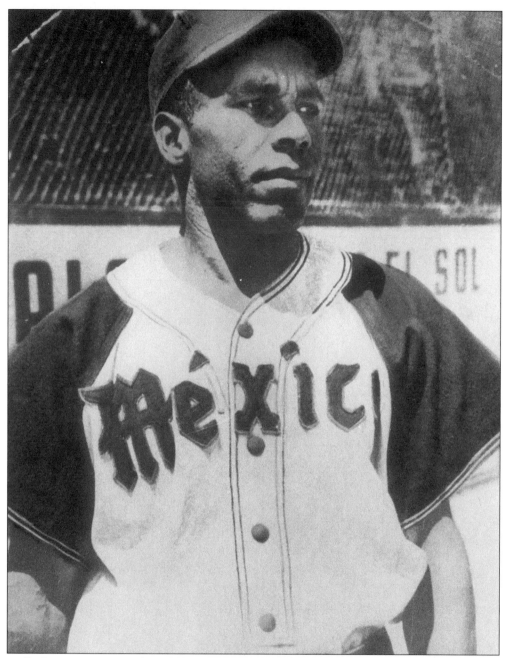

Hall of Famer Ray "Dandy" Dandridge started his professional career with Stars in 1933. He was one of the greatest third basemen in baseball history, black or white, and was enshrined in Cooperstown in 1987. It was often said of the fine-fielding, bow-legged superstar "that a train would stand a better chance of going through Dandy's legs than a baseball." He played in the Mexican Leagues in 1940–43 and 1945–48. (Courtesy of NoirTech Research, Inc.)

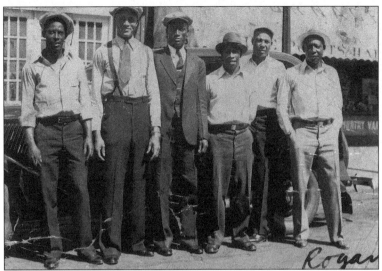

Pictured are members of the 1934 Kansas City Monarchs team. They are, from left to right, Newt Allen, T.J. Young, Turkey Stearnes, Eddie Dwight, Dink Mothell, and Wilber "Bullet" Rogan. That year the Monarchs took part in a national semi-pro Denver Post tournament, the first appearance of a black team in the tournament. The powerful Monarchs lost to the House of David team, which featured Satchel Paige. Stearnes was back with the American Giants in 1935. He led the league in hitting with a .430 average and played in the all-star game. Back with the Detroit Stars in 1937, he was selected to the East-West squad again, marking the only time a Detroit Star appeared in an East-West game. From 1938 until 1941, Stearnes played with the Kansas City Monarchs, making the last of five all-star appearances in 1939. (Courtesy of John Holway.)

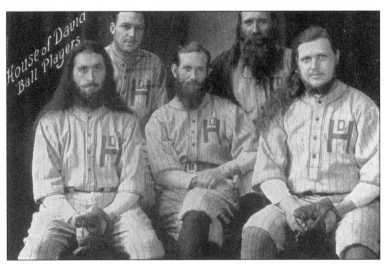

The House of David baseball team was part of a religious community based in Benton Harbor, MI, and hosted its own amusement park. Like the Washington Generals, who play the Harlem Globetrotters, the long-haired, bearded team traveled across the Midwest and regularly played against the toughest Negro League teams of the day, including the Stars. Unlike their basketball counterparts, sometimes they won. (Courtesy of Dick Clark.)

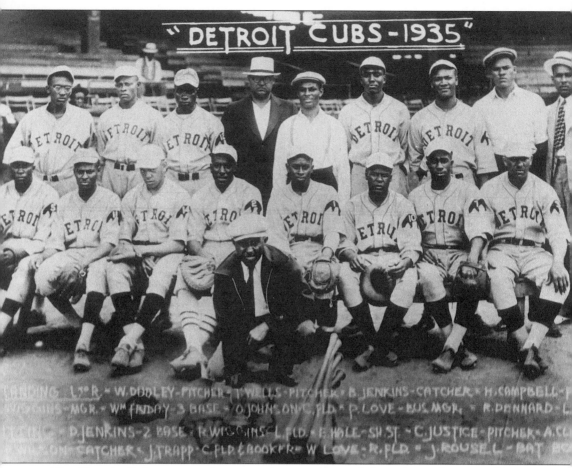

The Detroit Cubs were a barnstorming semi-pro club with no league affiliation. Pictured are players of the 1935 team. They are as follows, from left to right: (front row) D. Jenkins, Robert Wiggins, E. Red Hale, Charley Justice, Allie Clarke, Felton Wilson, James Trapp, and William Love; (back row) William Dudley, T. Lou Wells, Barney Jenkins, Hunter Campbell (president), J. Wiggins (manager), William Friday, O. Johnson, P. Love, and Richard Dennard. Kneeling in the front row is batboy J. Rousel. (Courtesy of National Baseball Hall of Fame.)

Heavyweight champ Joe Louis (center) and Star catcher "Pepper" Daniels (far left) are pictured talking shop on a camping trip. When Louis defeated German Max Schmeling in 1938, he became one of the first black athletes to gain acceptance by white America. White attitudes towards African Americans as role models and sport heroes were changed and, as a result, made Jackie Robinson's transition from the Negro leagues into the white majors in 1947 a less daunting task. (Courtesy of Leon T. Daniels Jr.)

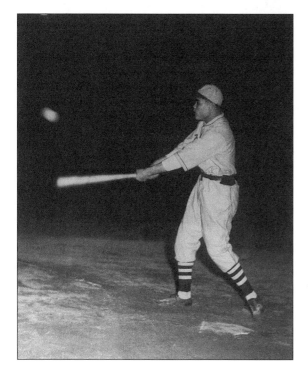

Packing a powerful punch in his right hand, slugger Joe Louis bats from the left side. Louis filled the roster of his softball team, the Brown Bombers (a.k.a. Joe Louis Bombers) with boyhood friends from the Black Bottom section of Detroit. Louis' mother, Lily Brooks, lived on McDougall. According to reports by the end of the 1938 season, the team, which played charity games across the country, had cost Louis about $50,000. (Courtesy of NoirTech Research, Inc.)

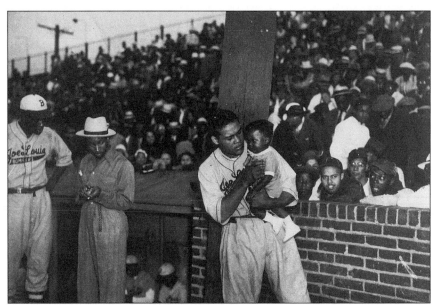

Detroit native Joe Louis considered at one time buying his own Negro League franchise using Detroit as its home base. Realizing that some owners in the league were reputed to have been involved in questionable dealings, Louis did not pursue this dream. Instead he formed the Brown Bombers softball team, on which he played first base. He cuddled kids between innings. (Courtesy of Mister Sports Collectibles.)

A pensive and quiet Joe Louis relaxes in the dugout, showing no likeness of the "Dark Destroyer" label penned by writers after seeing the heavyweight champ demolish challengers in the ring. Some writers called Louis "a credit to his race." Sportswriter Jimmy Cannon countered, "Yes, Louis is a credit to his race—the human race." (Courtesy of NoirTech Research, Inc.)

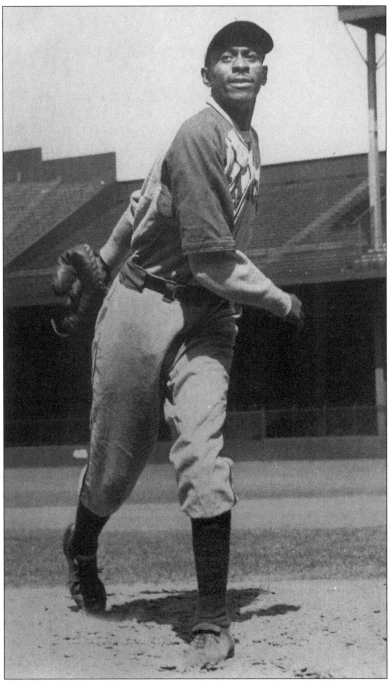

When it comes to Negro League baseball, no name is more recognizable than that of pitcher Leroy "Satchel" Paige. Paige, in his 1941 Monarchs uniform, is shown taking some warm up tosses before a game at Briggs Stadium. During the early forties, when Detroit was without a Negro League team, other league teams regularly filled the void with action packed games and engaging personalities like "Satch." (Courtesy of Richard Bak.)

This site at 8 Mile Road and Schoenherr Road was once the home of the Motor City Speedway. In 1942, the Detroit Giants, members of the short-lived Negro Major League, used this as a home field. The park located in northeast Detroit was one of two home fields for the Giants. (Courtesy of Dick Clark.)

The other home field for the Giants was this park at Livernois Avenue and Elmhurst Street, site of Bob Sage's Sports Park. Located in Southwest Detroit, the park held an estimated 15,000 spectators. The Motor City's entry played in the Negro Major League during the only season the league operated. (Courtesy of Dick Clark.)

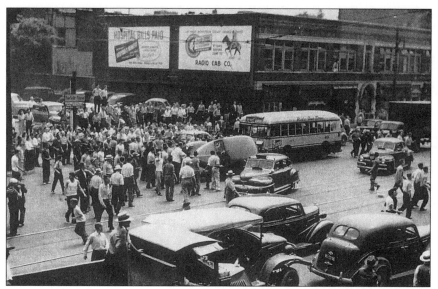

On the night of June 20, 1943, an altercation between a white man and a black man occurred on the Belle Isle Bridge. One rumor was a white woman had been raped and killed by a group of black men. Another rumor was a black woman had been thrown off the Belle Isle Bridge by a white mob. By the next morning, rioting was widespread. (Courtesy of Burton Historical Collection of the Detroit Public Library.)

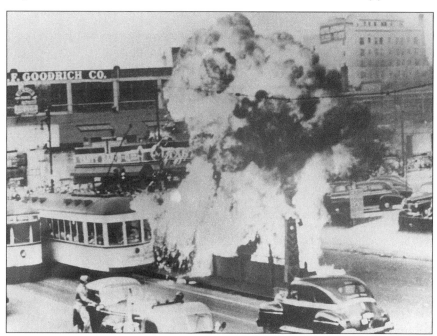

With businesses and streetcars ablaze on the morning of June 21, the racial tensions that had caused the riots were raised to a new level. Three white youths, the youngest 16, shot 58-year-old black Moses Kiska with a rifle while he was waiting on a street car just down from Mack Park, the former home of the Detroit Stars. (Courtesy of Burton Historical Collection of the Detroit Public Library.)

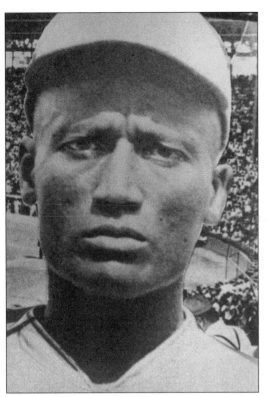

During his career, which included time with Detroit Black Sox in 1942 and the Toledo Cubs in 1945, Turkey Stearnes hit some of the longest homeruns in Negro League history. Stearnes is credited with hitting one out of Compton Park, the home of the St. Louis Stars. He also hit one out of Mack Park's 313 area code. (Courtesy of Dick Clark.)

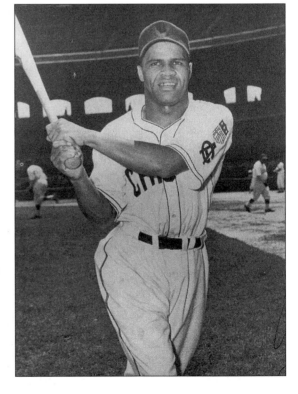

Showing the swing that made him famous is Chicago American Giant Art "Superman" Pennington. In a game against the Kansas City Monarchs at Briggs Stadium in front of 44,000 fans, Pennington, facing pitcher Johnny Markham in the second game of a double header, hit a home run out of the park over the stadium's right field roof—a 440-foot blast. (National Baseball Hall of Fame.)

Detroit resident Cecil Kaiser played for the semi-pro Detroit Stars (1939–1940) and the Motor City Giants (1941–1944) before making the black majors in 1945 when he joined the Homestead Grays. His arsenal included a good fastball and a nice selection of off-speed pitches. Kaiser recalled, "I played with some of the greatest players from all around the world. I have great memories." Kaiser, well past the biblical three score and ten, still works every day at Goodwill Printing in Ferndale. (Courtesy of Dick Clark.)

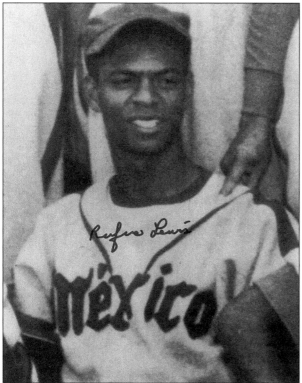

Shown here in a Mexico City Reds uniform, former Negro league pitcher and Detroit resident Rufus Lewis was a member of the World Champion Newark Eagles team of 1946. During his 1946 rookie year, Lewis had a record of six wins and one loss in league games and won the seventh and deciding game of the World Series. (Courtesy of Rufus Lewis.)

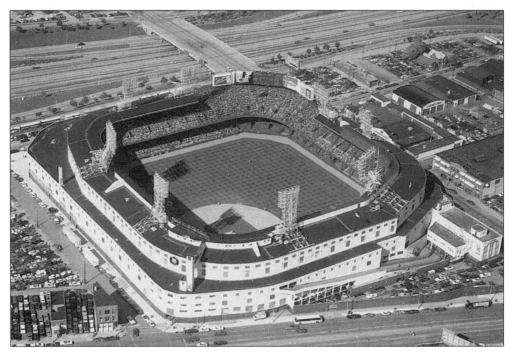

Briggs Stadium (above), as Tiger Stadium was known from 1938–1960, was the home of the Detroit Stars in the 1950s. In 1948, a field lighting system was installed, making it the last American League stadium to install lights. The stadium was used as a neutral site for Negro League games in the 1940s. It was during this period that Baltimore Elite Giants outfielder Henry "Jumbo" Kimbro (pictured at left, crossing the plate) hit a home run out of the stadium. (Courtesy of Dick Clark and NoirTech Research, Inc.)

Shown here are Charles "Red" House (left), with Jackie Robinson (middle) and an unidentified player in 1947. House, a third baseman, played for the Detroit Stars in 1937 and 1941, and the Detroit Wolves in 1947. The Wolves played at Dequindre Park, two blocks north of Davison. House was a good defensive hot corner man and an average hitter at the plate. Red also spent part of 1941 with the Detroit Black Sox. Jackie Robinson was making a guest appearance at second base on behalf of Wolves manager Dizzy Dismukes, who assisted Robinson in signing a Brooklyn Dodger contract in 1945. (Courtesy of Red House and Lucky Smith.)

Detroit native Ron Teasley, who will be remembered by many as a local high school teacher and coach, played briefly for the 1948 New York Cubans of the Negro National League before signing with the Brooklyn Dodger organization in 1948. Teasley starred for several local semi-pro teams that regularly competed against major Negro League teams. "The Detroit Stars and the Detroit Wolves gave inspiration to blacks who passed this feeling of esteem onto their children," Teasley boasted. (Courtesy of Ron Teasley.)

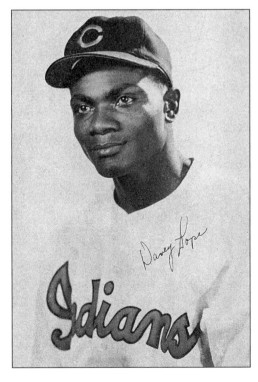

In 1947, David Pope played for the Detroit Senators, a semi-pro team with Cool Papa Bell as manager. Pope won the 1952 American Association batting title, hitting .352, to earn a shot with the Cleveland Indians. In his first game in the majors on July 1, 1952, he crashed into the right field wall and bruised his chest chasing a foul hit by Joe DeMaestri of the St. Louis Browns. "I hit the cement top of the wall with my chest and bounced about 10 feet. I thought I was dead," said Pope. Pope survived to play four seasons with Cleveland and the Baltimore Orioles. (Courtesy of NoirTech Research, Inc.)

Melvin Duncan, a pitcher, had a six-year career in the Negro Leagues with the Kansas City Monarchs and the Detroit Stars. From 1949 through 1955, Duncan used a good fastball and hard breaking curve to become a valuable team member. After retiring from professional baseball, he stayed in the Detroit area, where he lives today. (Courtesy of Melvin Duncan.)

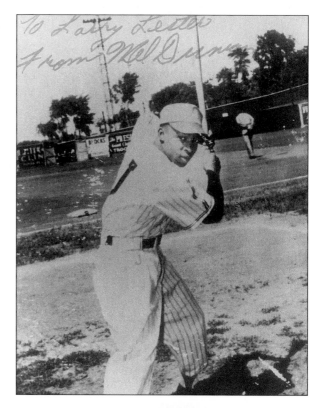

The 1950 Grand Rapids Black Sox were one of the first teams owned by future Detroit Stars owner Ted Rasberry. Pictured are the following, from left to right; (front row) Reuben Smartt, Eddie Perry, Robert Norman, Ted Rasberry, Lloyd Cannimore, Ray Miller, and Jake Robinson; (back row) Joe Smith, Herm Purcell, Olan "Jelly" Taylor, Thomas Knight, Bud Chaney, Henry Saverson, and Sammy Robinson. Saverson would later play for the Detroit Stars in 1954 and 1955. (Courtesy of Grand Rapids Public Library.)

Not only was he the owner of the Grand Rapids Black Sox, Ted Rasberry was a player and manager. Rasberry, second from left, gives instructions to Rube Smartt (far left), Olan Taylor (second from right), and Henry Saverson (far right). The light-hitting Olan "Jelly" Taylor was noted for his fancy fielding at first base. He played for several Negro League teams from 1934 to 1946. He finished his career with the semi-pro Grand Rapids club. (Courtesy of Grand Rapids Public Library.)

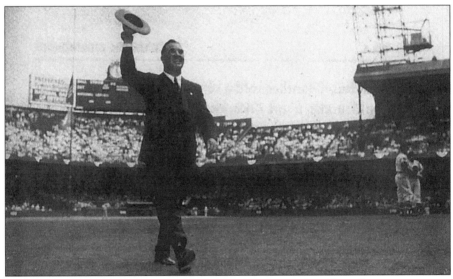

Major League Baseball Commissioner A.B. "Happy" Chandler, former governor of Kentucky, waves to the fans at Briggs Stadium in 1951. Although every other major league team was against the Brooklyn Dodgers and Branch Rickey's decision to sign Jackie Robinson, Chandler approved the plan. Due to the fact that he had been raised in the South, many thought Chandler would keep the major's color barrier in place. Instead, his view was "I don't believe in barring Negroes from baseball just because they are Negroes." (Courtesy of Dick Clark.)

Beginning in 1936, Walter O. Briggs owned both the Detroit Tigers and Navin Field. Briggs expanded Navin Field and changed the name to Briggs Stadium. He stationed guards at the stadium's concession stands during Negro League games because he believed the black fans would attempt armed robbery. After the integration of the majors in 1947, Briggs' Tigers did not sign an African-American or Latin-American player until 1958. Sportswriters at that time coined the phrase "no jiggs with Briggs." (Courtesy of Richard Bak.)

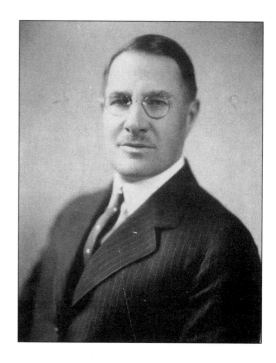

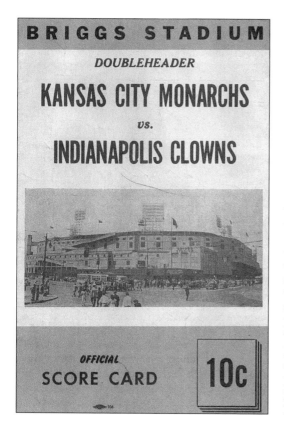

A rare 1954 scorecard from a double header at Briggs Stadium between the Kansas City Monarchs and the Indianapolis Clowns. The front of the card depicts Briggs Stadium as it appeared in the 1950s when the game was played. The most interesting aspect of the games is the lead off hitter for each team in both games. They were women, Toni Stone of the Monarchs and Connie Morgan for the Clowns. Stone played in the Negro Leagues in 1953 and 1954, while Morgan played in 1954. (Courtesy of Dick Clark.)

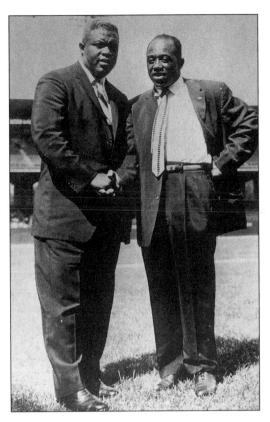

Former Brooklyn Dodger Jackie Robinson (left) and Grand Rapids business man, Cleveland Indians scout, and owner of the Detroit Stars Theodore Rasberry share a handshake. Rasberry, who was one of a handful of people that felt the Negro Leagues were still an important showcase for black players, bought the Kansas City Monarchs, Robinson's former team, from Tom Baird in 1955. (Courtesy of Ted Rasberry.)

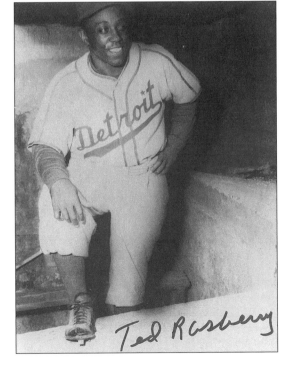

Ted Rasberry was owner, manager, and part-time player for the Detroit Stars in the late fifties. When he purchased the Kansas City Monarchs in 1955, he became first owner in baseball to own two clubs in the same league. His Monarchs continued to win championships, while his Stars fought diligently to play .500 ball. (Courtesy of Ted Rasberry.)

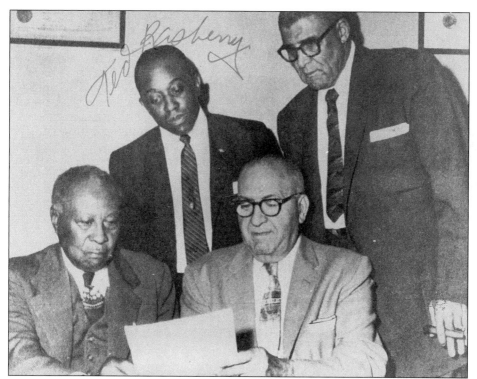

Pictured is a meeting of Negro American League officials in 1955. From left to right are Dr. W.S. Martin (secretary and co-owner of the Memphis Red Sox), Ted Rasberry (vice president and owner of the Detroit Stars and Kansas City Monarchs), Dr. J.B. Martin (president and owner of the Chicago American Giants), and Dr. B.B. Martin (treasurer and co-owner of the Memphis Red Sox). Each of these men believed that baseball fans would eventually return to the Negro Leagues despite the integration of the majors. They were wrong. (Courtesy of Ted Rasberry.)

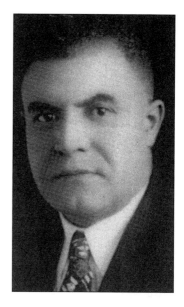

John B. Martin, or simply J.B., was a dentist and co-owner, along with his brothers W.S., A.T., and B.B., of the Memphis Red Sox. In Memphis, he built a ballpark with built-in living facilities for his Red Sox players. The Meharry Medical College grad was a visible leader in the Republican Party, and a member of the Cook County (Illinois) Commission. He moved to Detroit late in life, and passed away at the Cedar Knoll Rest Home. in Grass Lakes, Michigan. (Courtesy of Shelby County Public Library.)

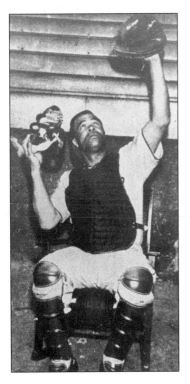

Known as the rocking chair catcher for his ease at receiving pitches, Lloyd "Pepper" Bassett started his career with the 1934 New Orleans Crescent Stars. An outstanding receiver, Bassett made eight appearances in the East-West All-Star game—the most of any catcher except Josh Gibson. Bassett closed out his leisure pursuit in 1954 with the Detroit Stars. (Courtesy of NoirTech Research, Inc.)

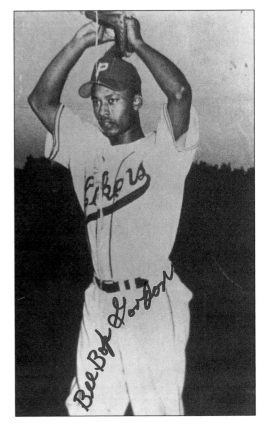

He put the "bop" in "bee-bop." Herald "Bee-Bop" Gordon had a curveball that dropped like Niagara Falls. Gordon said his career highlight came on August 15, 1954, at Briggs Stadium, while pitching for the Detroit Stars. He edged out Leroy "Satchel" Paige, 2–1, in a pitcher's duel. "The reason I remember the date so well is because my daughter Pamela Jill was born the next day," said Gordon, a father of two daughters and three sons. Gordon acquired his nickname after the old time bee-bop glasses that fashionable folks wore. (Courtesy of Herald Gordon.)

Charles "Sleepy" Chatman toiled under Detroit manager Ed Steele. With outstanding control and using a three-quarter overhand delivery, Chatman's best pitch was his curve. He proved to be very effective against left-handed hitters. The Memphis, TN, native played for Detroit teams from 1955 through 1959. (Courtesy of Charles Chatman.)

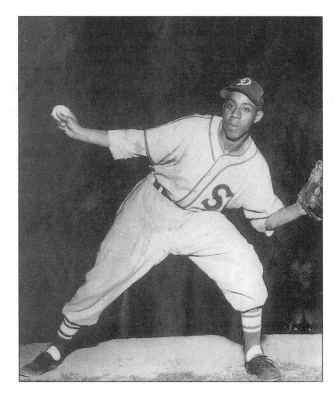

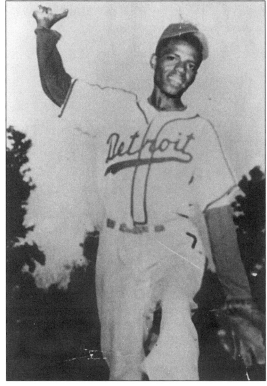

Eugene Scruggs played for the Stars in 1956 and 1957. With a good fastball and a decent curve ball, Scruggs was an important part of the Stars' staff. While not overpowering, Scruggs used smarts and control to win his games. Scruggs closed out his professional career after playing the 1958 season with the Kansas City Monarchs. (Courtesy of Eugene Scruggs.)

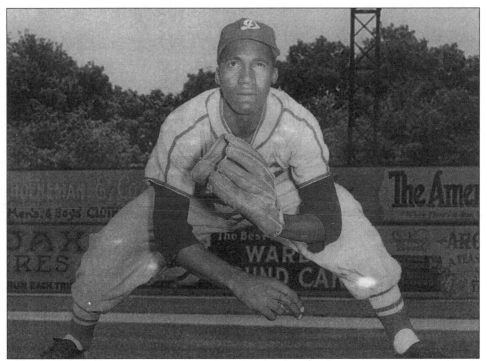

Cuban pitcher Pedro Sierra played for the Detroit Stars from 1956 through 1958. After a distinguished playing career, he attended the University of Maryland in pursuit of a B.S. degree in Human Services. In 1994, he served as a consultant to the movie *Major League II*, starring Charlie Sheen and Tom Berenger. (Courtesy of Pedro Sierra.)

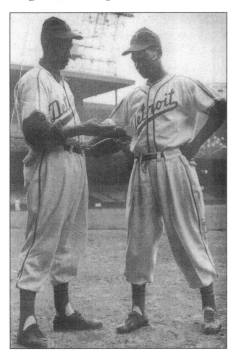

During his first season with the Stars, Sierra was selected to pitch in the annual East-West All-Star game at Comiskey Park in Chicago. Here at Briggs Stadium, Sierra (left) is teaching the fine points of pitching to Manuel Quevedo prior to the 1956 contest. Known for his fabulous curve ball, Sierra was signed by the Minnesota Twins in 1962. In 1969, he led the Provincial League in wins (14), shutouts (4), and was named team MVP. Later, in 1970, he was invited to the Washington Senators training camp. (Courtesy of Pedro Sierra.)

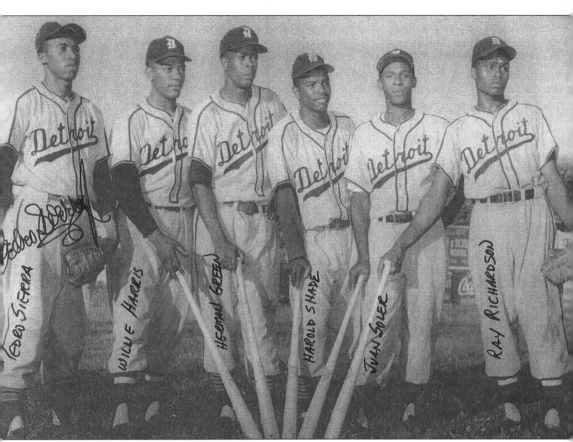

In the Negro Leagues, a baseball player saw more of the country than most major league players ever dreamed of. At times, Negro League teams played seven games in seven different cities in seven days. Pictured are members of the 1956 Detroit Stars in St. Joseph, Missouri. They are, from left to right, Pedro Sierra, Willie Harris, Herman Green, Harold Shade, Juan Soler, and Ray Richardson. (Courtesy of Pedro Sierra.)

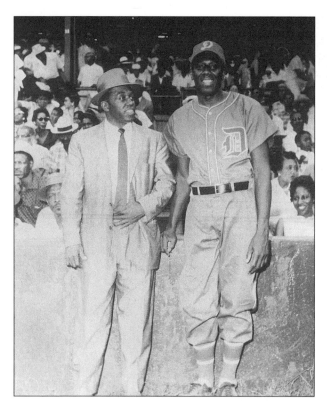

For the upcoming 1958 season, entrepreneur Ted Rasberry formed a new team and anointed legendary Harlem Globetrotter Reese "Goose" Tatum as pseudo-owner. That year, Rasberry changed the name of the team from the Stars to the Clowns and added legendary baseball clown Prince Joe Henry to perform stunts with Tatum. The experiment apparently did not yield the desired result, as the team reverted to its original name the next season. (Courtesy of Ted Rasberry.)

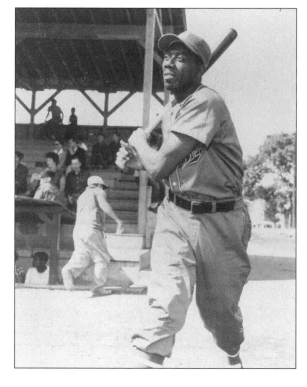

Taking a practice swing in a Detroit Clowns uniform is Goose Tatum. While he is better known as a basketball player, Tatum played first base and outfield for the Birmingham Black Barons and the Cincinnati-Indianapolis Clowns of the Negro League from 1939 through 1949. Tatum's time with the Clowns in 1958 marked his return to professional baseball. (Courtesy of NoirTech Research, Inc.)

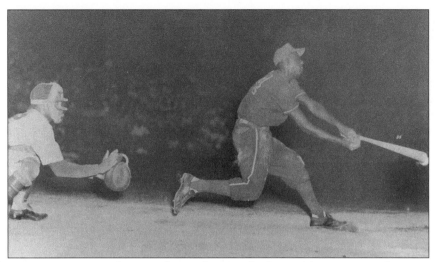

Taking a swing in a real game shows the gangly Goose Tatum out in front on a pitch. The basketball legend out of El Dorado, AR, acquired the name "Goose" from the way he flapped his arms, which had a spread of seven feet, three inches. Although he excelled at basketball and struggled to learn baseball, Tatum often claimed he like baseball best. He started his baseball career in 1939 with the Louisville Black Colonels, and played for 11 years before rejoining the league in 1958 for a last laugh. (Courtesy of NoirTech Research, Inc.)

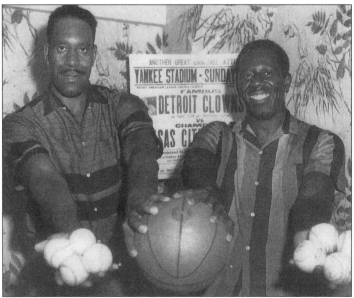

Before two-timers Bo Jackson and Deion Sanders played two sports, there was Nathaniel "Sweetwater" Clifton (left) and Reece "Goose" Tatum. They played on the 1958 Detroit Clowns team and later the Harlem Globetrotters. Sweetwater, so named because of his craving for soda pop, played two years in the Negro Leagues, the first in 1949 with the Chicago American Giants. In 1950, Clifton became the first black player with the New York Knicks of the National Basketball Association. (Courtesy of Dick Clark.)

Shown here in 1958 are Detroit Clowns Reece "Goose" Tatum (left) and Joe Henry, in a dress coat and holding a top hat. Props played an integral part with the clown teams that for decades were a part of the barnstorming teams of the Negro leagues. Henry played a few innings of the game in the tails and top hat. It was an old and very popular tradition among baseball clowns. (Courtesy of Joe Henry.)

Joe Henry meets Goose Tatum in the above photo. The tandem of comedians provided the entertainment for Ted Rasberry's Clowns. The team finished the season with 21 wins against 26 loses, five-and-a-half games behind the champion Kansas City Monarchs. Official stats released by the Howe News Bureau show Henry batted .284 with three home runs and 15 RBIs. He finished seventh in the race to the batting title. Tatum appeared in less than 10 games and his stats were not published. (Courtesy of Joe Henry.)

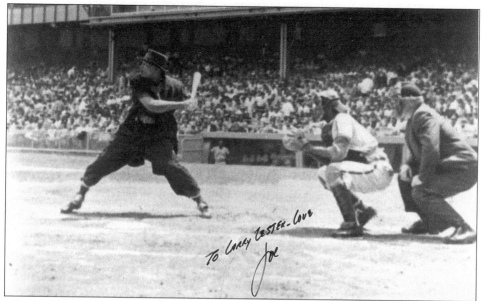

In the hot summer heat, Joe Henry dons tails and top hat to entertain the fans. He painted his shoes red and sometimes turned his back to the pitcher during the windup. Recalling his days in the league he said, "As I look back, it was the best experience I ever had in my life…the Negro Leagues took me to just about every state in the country and Canada. I had an offer from Goose Tatum to go with him to Europe, but it was across the water and I didn't like to fly." (Courtesy of Joe Henry.)

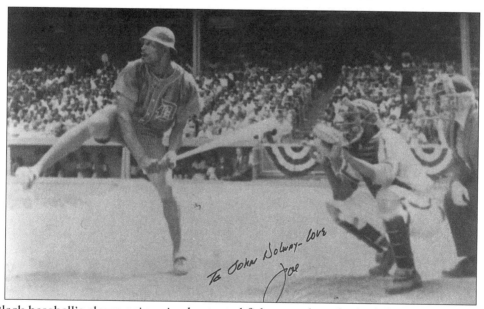

Black baseball's clown prince in shorts and fisherman hat, the high kicking Joe Henry showboats at the plate as a member of the 1958 Detroit Clowns. Henry began his professional career with the Memphis Red Sox in 1950, where he played second and third base. He was with the Red Sox through the 1952 season. (Courtesy of Joe Henry and John Holoway.)

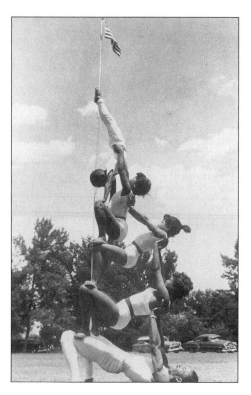

The Flying Nesbitts, a family of gymnasts hired by Ted Rasberry, raise the American flag at a game in Detroit. Acts such as this, as well as foot races, performances by famous musicians, and pre-game antics by players, were popular at Star games. However, when game time rolled around, the antics stopped and top-notch baseball took over. (Courtesy of Ted Rasberry.)

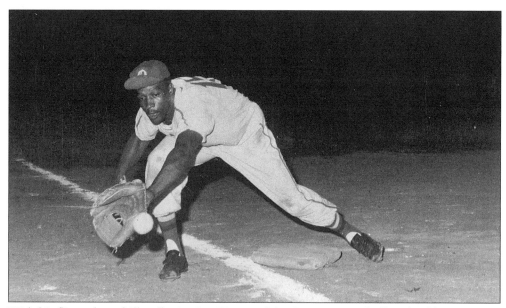

With his flipped cap bill, talkative Joe Henry of the Stars snags a ball at third base. Henry re-entered baseball in 1958 after a four-year retirement. He had last played in 1954 for Mt. Vernon, a minor league in the Mississippi-Ohio Valley League. He closed out his career with the Detroit Stars in 1959. Currently, he writes poetry out of his East St. Louis office. (Courtesy of NoirTech Research, Inc.)

Sherwood Brewer, appearing in his Harlem Globetrotters baseball uniform, spent most of his career with the Indianapolis Clowns and the Kansas City Monarchs, serving as the Monarch's manager in 1960. Brewer, a shortstop and second baseman, played in four East-West All-Star games. His Detroit stay was for one year, 1958, with the Clowns. (Courtesy of NoirTech Research, Inc.)

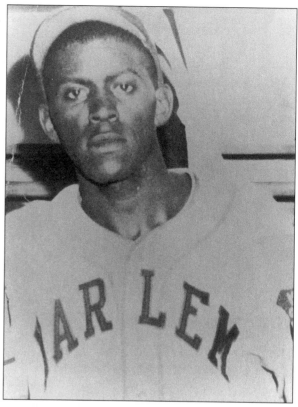

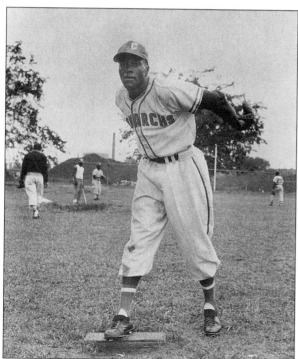

Ben Adams, shown here in a Kansas City Monarchs uniform, pitched for the Detroit Clowns in 1958 and the Detroit Stars the following year. Adams had a vast array of pitches along with superb control, making him an effective mound presence. He had a good, but not overpowering, fastball that he effectively used for the desired results. (Courtesy of NoirTech Research, Inc.)

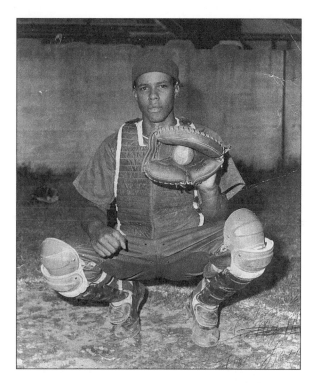

Catcher Larry LeGrande, 19 years old, played for the Detroit Clowns in 1958 and the Detroit Stars in 1959. A good handler of pitchers, LeGrande was a talented defensive catcher with a bazooka arm, which he used effectively against opposing baserunners. In 1960, he had a shot with the New York Yankees farm club in St. Petersburg, FL. Although he was leading the team in RBIs, and the league in triples, he was cut, motivating LeGrande to join the Satchel Paige Traveling All-Stars. (Courtesy of Larry LeGrande.)

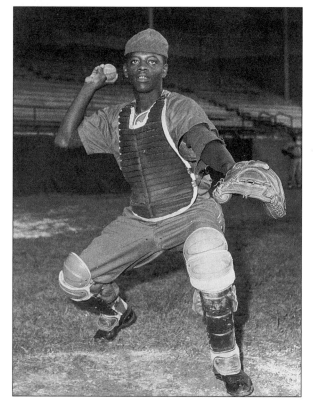

Sharing catching duties with LeGrande was Art Hamilton. Hamilton played with the Detroit Clowns in 1958, the Detroit Stars in 1959, and the Detroit-New Orleans Stars in 1960. He was an effective catcher who could handle all aspects of his position well. A good handler of pitchers, Arthur Lee could call a good game and was also a dangerous hitter. (Courtesy of NoirTech Research, Inc.)

Robert "Bob" Haywood played for the Detroit-New Orleans Stars in 1960. Haywood was a talented fielder with decent speed and a good arm. He was known to struggle at the plate on occasion but, overall, he helped the team more often than hindered it. His last year in professional ball was 1960. (Courtesy of NoirTech Research, Inc.)

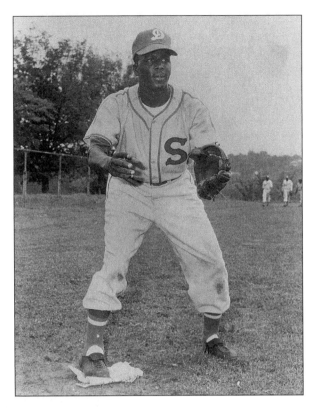

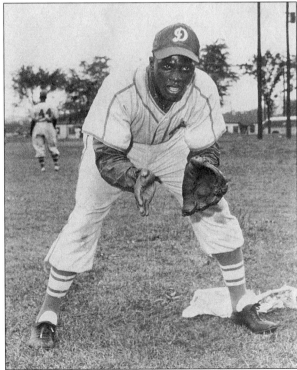

Chicago native Don Bonner played third base for the Stars in 1959 and 1960. During his career, Bonner was often compared to the Yankee third sacker Hector Lopez. Scouted as an average fielder, Bonner could help his team best when he came to the plate. He hit for a .321 average with eight homers in 1960. (Courtesy of NoirTech Research, Inc.)

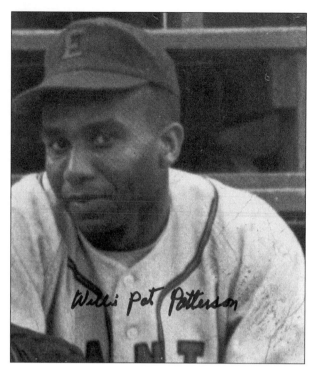

Willie "Pat" Patterson was an outstanding catcher and third baseman for several teams including the New York Cubans, Chicago American Giants, Philadelphia Stars, and the Memphis Red Sox. As a member of the Detroit Stars in 1954, he won the Negro American League batting title. Patterson finished his career with the Stars in 1960, the last season that Detroit would field a league team. (Courtesy of Pat Patterson.)

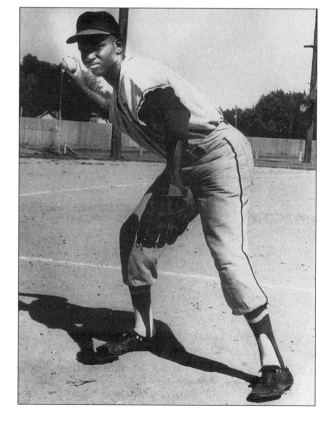

Willie Hardwick was a sensational outfielder for the Stars in their last league years of play. Hardwick played centerfield like another Willie we all know (Willie Mays, of course). In 1962, "Say Hey" Hardwick hit a towering three-run homer over the left field fence at the all-star game in Kansas City, helping the West team defeat the East, 5–2. (Courtesy of NoirTech Research, Inc.)

Six
THE RECOGNITION YEARS

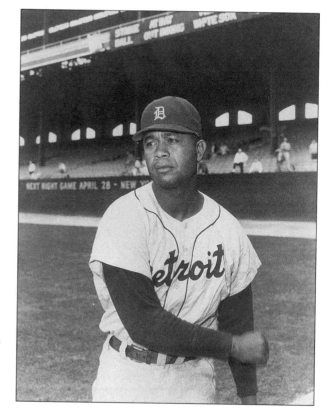

Larry Doby broke the American League color barrier on July 4, 1947, with the Cleveland Indians. He was the first black player to lead the league in home runs and RBIs. Doby spent the majority of his major league career in Cleveland, but joined the Detroit Tigers for 19 games in 1959, at the age of 36. The former Newark Eagle sensation was selected to the National Baseball Hall of Fame in 1998. (Courtesy of NoirTech Research, Inc.)

This rare photo shows Maury Wills in a Detroit Tigers uniform during spring training of 1959. The Tigers' management, in one of their greatest mistakes, decided against keeping the drafted Wills and let him go back to the Los Angeles Dodgers. Wills played in 83 games with the Dodgers that year, beginning a career that spanned 14 years and saw him become the first player to steal more than 100 bases in a season, en route to 586 career thefts. (Courtesy of Richard Bak.)

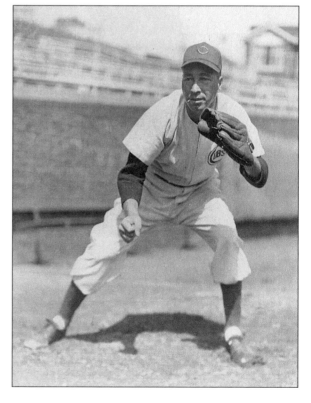

"Toothpick" Sam Jones, with toothpick on the job, hurled for the Homestead Grays and Cleveland Buckeyes in the late 1940s before joining organized baseball in 1950. He earned a spot with the Detroit Tigers in 1962 at the age of 37. That season Jones appeared in 30 games, winning two and losing four with 73 strikeouts and an ERA of 3.65. (Courtesy of Dick Clark.)

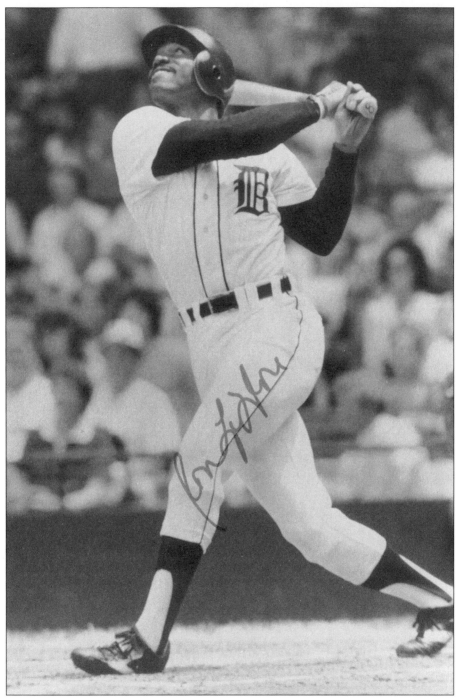

In 1978, Detroit Tigers outfielder Ron LeFlore became the first non-Hall-of-Famer to have a TV-movie made about his career, called *One in a Million*. That year he led the American League in steals, with 68. Two years later, LeFlore stole 97 bases for the Montreal Expos and became the first player to win stolen base titles in the National and the American League. (Courtesy of the National Baseball Hall of Fame.)

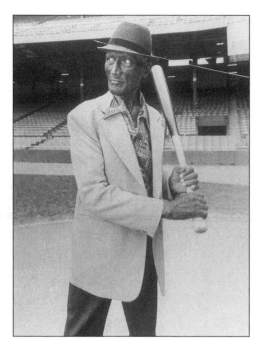

The greatest black baseball player in Detroit baseball history, Norman "Turkey" Stearnes, takes his last turn at bat. Late in his life and not long before his death in 1979, Stearnes visited Tiger Stadium, where he plied his trade with the Stars. After his retirement from baseball, Stearnes was a regular at Detroit Tigers games, where he preferred to sit with the bleacher bums. Number eight was truly great. (Courtesy of Richard Bak.)

Lincoln Memorial Park Cemetery—the final resting place of Detroit's black legend. Norman "Turkey" Stearnes died of a perforated ulcer on September 4, 1979. Today, the Nashville, TN, native's grave remains unmarked. His oldest daughter Rosilyn remembers, "My father was not only a great ballplayer, but he was a wonderful person and we loved him dearly. We owe our successes and upbringing to him." (Courtesy of Dick Clark.)

After the death of Turkey Stearnes, his widow, Nettie, remained a vocal advocate for the enshrinement of her husband in the National Baseball Hall of Fame. As of this writing, Stearnes is considered to be the most talented player from the Negro Leagues not inducted into baseball's hallowed Hall of Fame in Cooperstown, NY. (Courtesy of Dan Lori.)

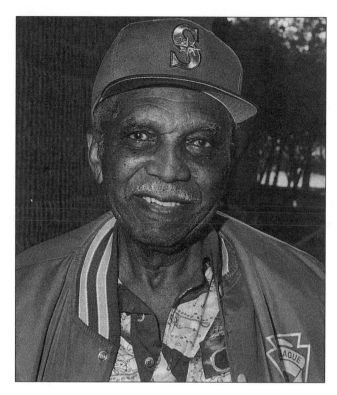

Third baseman William "Bobby" Robinson played third for the Detroit Stars from 1929 through the end of the 1931 season. Bobby batted .309 in 1929. He was a talented defensive player and referred by some as "the human vacuum cleaner." "I never played very deep, as most players did, and still do. I probably only played five or six feet behind the bag," said Robinson, shown here at age 96. "Pie Traynor was the one I modeled myself after; he was a great one." As to his secret for longevity, "I was in bed every night between 10:30 and 11, no matter where I was," claimed Robinson. (Courtesy of Lisa Feder.)

The Stars of 1931 were unique. They only finished in fourth place with a 32–36 won-lost record, 19 games behind the St. Louis Stars. However, they can boast of having four players who lived into their nineties: William Owens (pictured here, he died at age 97 in 1999), Bobby Robinson (96 and still working as a brick mason), Saul Davis (who died at 93 in 1994), and Ted "Duty" Radcliffe (94 and still chasing). Owens, an infielder, earned a footnote in history as the last surviving player from the Eastern Colored League. (Courtesy of Lisa Feder.)

114

Saul "Rareback" Davis Jr. as he appeared at 90 years old. He claimed he was born in "the backwoods of the bayou," somewhere between Louisiana and Arkansas. The discoverer of Satchel Paige, he voiced his secret for longevity: "I'd tell people to try to be themselves and not try to be what the other fellow is. Be yourself! There's nobody who can give you anything but yourself." (Courtesy of Charlene Furrow.)

Pitcher and catcher Ted "Double Duty" Radcliffe played for the Detroit Stars in 1928, 1929, and part of 1931. Radcliffe was forever immortalized in baseball lore when in 1932 he caught for Satchel Paige in the first game of a doubleheader and then pitched a shutout to win the second game. His hands show it. New York sports columnist Damon Runyon witnessed the games and the next day in his column dubbed Radcliffe "Double Duty." Now in his nineties, Duty claims, "I didn't drink. Never went to nightclubs. I was kind of a quiet fella." (Courtesy of Lisa Feder.)

In 1992, Perry Hall, right after turning 91, signs a box of baseballs in the presence of future National League president Len Coleman. The speedy Hall played third base and pitched occasionally for the Stars in 1921–22 and 1926. He credits his speed to having to beat his 18 brothers and sisters to the dinner table. Hall played for 25 years before driving a cab became his profession. (Courtesy of NoirTech Research, Inc.)

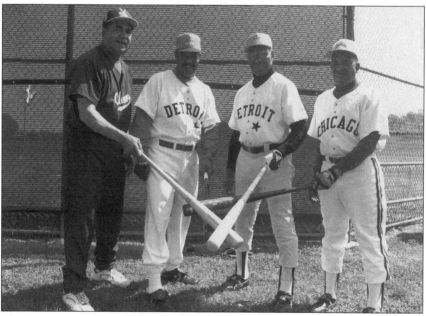

In 1996, a group of die-hard Negro Leaguers gathered on the sandlot for a little stickball. From left to right they are Chuck Harmon (72 years old and former Indianapolis Clown), Sonny Webb (age 61, 1958 Clowns), Ron "Bunny" Warren (64, 1959 Stars), and Don "Groundhog" Johnson (69, former Chicago American Giant). For some players, the competitive spirit never dies. (Courtesy of NoirTech Research, Inc.)

Bosom buddies Lester Lockett and 90 year-old "Double Duty" Radcliffe share old times thumbing through a Negro League calendar. Lockett and Duty played together for the Chicago American Giants and the Birmingham Black Barons. Radcliffe started his career with the Detroit Stars in 1928. He finished his "pitching career" in 1999, at the age of 97. The Schaumburg Flyers, out of Illinois, paid the legend $1,000 to suit up for a game against the Fargo-Moorhead RedHawks. (Courtesy of Ted Radcliffe.)

Negro League legend Ted "Double Duty" Radcliffe took part in the Tigers' Negro League Night in 1997. The former Star is one of the Negro Leagues' most beloved veterans and a great storyteller. In his autobiography, he claimed he won more games than Bob Feller and Dizzy Dean combined, belted out more hits than Stan Musial, and hit more home runs than Joe DiMaggio. (Courtesy of Dick Clark.)

Infielder Ozzie Virgil, the first black player for the Detroit Tigers, is shown taking part in the Tigers' Negro League Night in 1997. Although Virgil never played in the Negro Leagues, his role as the team's "barrier breaker" has secured his place in the Motor City's black baseball history. (Courtesy of Dick Clark.)

This picture, taken at the Tigers' Negro Leagues Night in 1997, shows what the dugout at Tiger Stadium may have looked like in the heyday of the Detroit Stars. The Tigers are one of a handful of major league teams that commemorate black baseball heritage on a regular basis. Each year the team dons Star uniforms and reunites former Negro League players as part of the celebration. (Courtesy of Dick Clark.)

Shown here is a group of Detroit residents and former Negro League players. The late Frank Duncan III (right) played with the Kansas City Monarchs and the Baltimore Elite Giants; Ron Teasley (standing at left) was a member of the New York Cubans; and Rufus Lewis (seated), pitched with the Pittsburgh Crawfords, the Newark Eagles, and the Houston Eagles. (Courtesy of Dick Clark.)

The Detroit Tigers' 1999 Negro Leagues Commemorative Night once again included on-field introductions of former Negro League players. Some of those present were, from left to right, Ron Teasley, Frank Duncan III, Willie Caldwell, unidentified, Clarence Jenkins, Joe Reynolds, Joe Moore, and unidentified. (Courtesy of Dick Clark.)

Other attendees at the 1997 celebration were former players. From left to right are James Moore, Joe Moore, Ron Teasley, Clarence "Pee Wee" Jenkins, unidentified, Herald "Bee Bop" Gordon, and unidentified. (Courtesy of Dick Clark.)

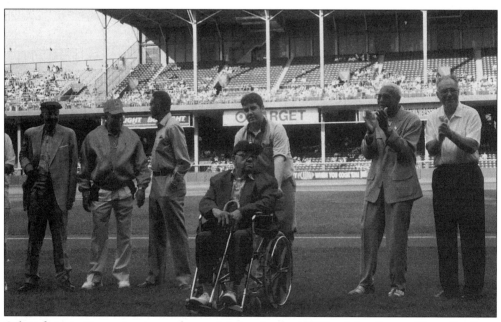

Other former Negro Leagues players joining in the 1998 celebration at Tiger Stadium included, from left to right, unidentified, Gene Collins, Frank Duncan III, Ted "Double Duty" Radcliffe (in wheelchair with escort), Buck O'Neil, and unidentified. In 1962, O'Neil joined the Chicago Cubs as the first black coach in the major leagues. (Courtesy of Dick Clark.)

All-Star second baseman Damion Easley wears a 1920 Detroit Stars uniform at the 1998 celebration. He is a talented defensive player in the mold of Negro League legend and former Detroit Wolves player Newt Allen. Easley joined the Tigers in 1996, and two years later became the first Tiger keystone man to play in an all-star game since 1986. (Courtesy of Dick Clark.)

Taking a back seat to no one, the "Mother of the Civil Rights Movement" Ms. Rosa Parks (middle in white jacket) is escorted from the field after the 1997 celebration of Negro Leaguers. Like Jackie Robinson, who broke baseball's color barrier in 1947, Ms. Parks broke Birmingham's segregated seating on buses in 1955–56, prompting Dr. Martin L. King Jr. and others to fight for equal accommodations in America. When Rosa sat down, justice stood up! (Courtesy of Dick Clark.)

Decked out in a Detroit Stars uniform is Tiger first baseman Tony Clark. Each year Clark hands out the "Tony Clark Negro League Scholarship," a $1,000 scholarship that goes to a Detroit public high school student who is involved and excels in athletics, academics, and community service. It is awarded each year at the Tigers annual Negro League commemorative game. (Courtesy of Dick Clark.)

Detroit Tigers first baseman Tony Clark, like current African-American players, benefited from the hardships of Negro League players. Clark, at 6'8", is the tallest switch-hitter to ever play in the majors. He joined the Tigers in 1995. In 1997 and 1998, he became the first Tiger to record 100 or more RBIs in two seasons since Rudy York did it in 1937 and 1938. (Courtesy of Dick Clark.)

Tony Clark "dressed to the nines" at the opening of the Discover Greatness exhibit at the African-American Museum. Clark's trivia link to black baseball is that he played part of the 1995 season with the Toledo Mud Hens. In 1884, Toledo was home of the American Association's Toledo Blue Stockings. One member of Blue Stockings was catcher Moses "Fleetwood" Walker, the first black to play in the major leagues. (Courtesy of Dick Clark.)

Tiger outfielder Brian Hunter (left) poses with a fan during the Discover Greatness exhibit. Hunter joined the Tigers in 1997 and stayed with the team through part of the 1999 season. During his first year with the team, Hunter joined Hall of Famer Ty Cobb and former Tiger Ron LeFlore as the only Tigers to steal 70 bases or more in a single season. (Courtesy of Dick Clark.)

Members of the Stearnes family, former Negro Leaguer Ron Teasley (second from right), and Nettie Stearnes (far right) take part in a opening festivities of the African-American Museum's Discover Greatness exhibit in 1999. The Stearnes family, many of whom live in Detroit, remain an important link to the city's Negro League legacy. (Courtesy of Dick Clark.)

Damion Easley (middle) takes a moment to pose during the Discover Greatness exhibit. In 1998 Easley had two 19 game hitting streaks, led the American League in fielding at his position, and his 90 RBIs as a second baseman were the most of any Motor City second sacker since 1938. (Courtesy of Dick Clark.)

Pictured is Tiger Stadium in its final days, before closing out the 1999 season. It was known as a hitter's ball park. In 1987 the Tigers hit more homers than any team in major league history, except for the 1961 New York Yankees team that included Mickey Mantle and Roger Maris. In 1980, the seats were replaced with new blue-and-orange plastic seats. A new scoreboard costing $2 million was later added. In 1986, a dome was suggested by then-mayor Coleman A. Young. The novelty never materialized. (Courtesy of NoirTech Research, Inc.)

Comerica Park is to open in April of 2000 at an estimated cost of $66 million. The construction sits on the edge of what was once known as Paradise Valley, which encompassed St. Antoine, Hastings, Brush, John R, Gratiot, Vernor, Madison, Beacon, Elmwood, and Lafayette Streets. It was the entertainment and business capital of Detroit's black community. (Courtesy of Dick Clark.)

The stadium, about a mile from old Tiger Stadium, will accommodate more than 40,000 vocal fans. The new facility is located across Woodward Avenue from the Fox Theatre, a famous showplace, where $1.50 used to buy a ticket to the Motown Revue, an annual holiday show featuring Motown's top acts—The Temptations, Supremes, Four Tops, Martha and the Vandellas, Little Stevie Wonder, Marvin Gaye, Smokey Robinson and the Miracles, and Mary Wells—all on one stage. (Courtesy of NoirTech Research, Inc.)

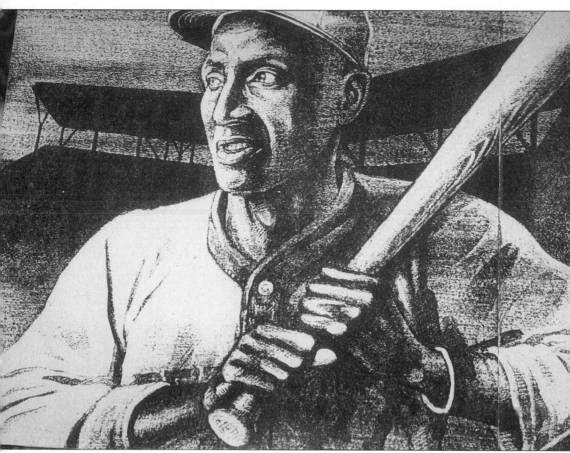

This unknown artwork of an unknown Norman "Turkey" Stearnes exemplifies the best of black baseball. Like a whisper in a hurricane, or a snowball in a blizzard, the slender, southpaw slugger was unnoticed, unheralded, and underrated. Turkey ran the bases, and roamed the outfield, with arms flapping, sprinting on his tipsy-toes, while putting fans on their heels in awe of his grace. Without a doubt, the five-time home run king is baseball's best kept secret, and the greatest player not in the Hall of Fame today. (Courtesy of Dick Clark.)